Wildflowers *of* Georgia

Marney & Colin —
Thanks for all your encouragment
and kind words at Foxhall 2002

Brooks

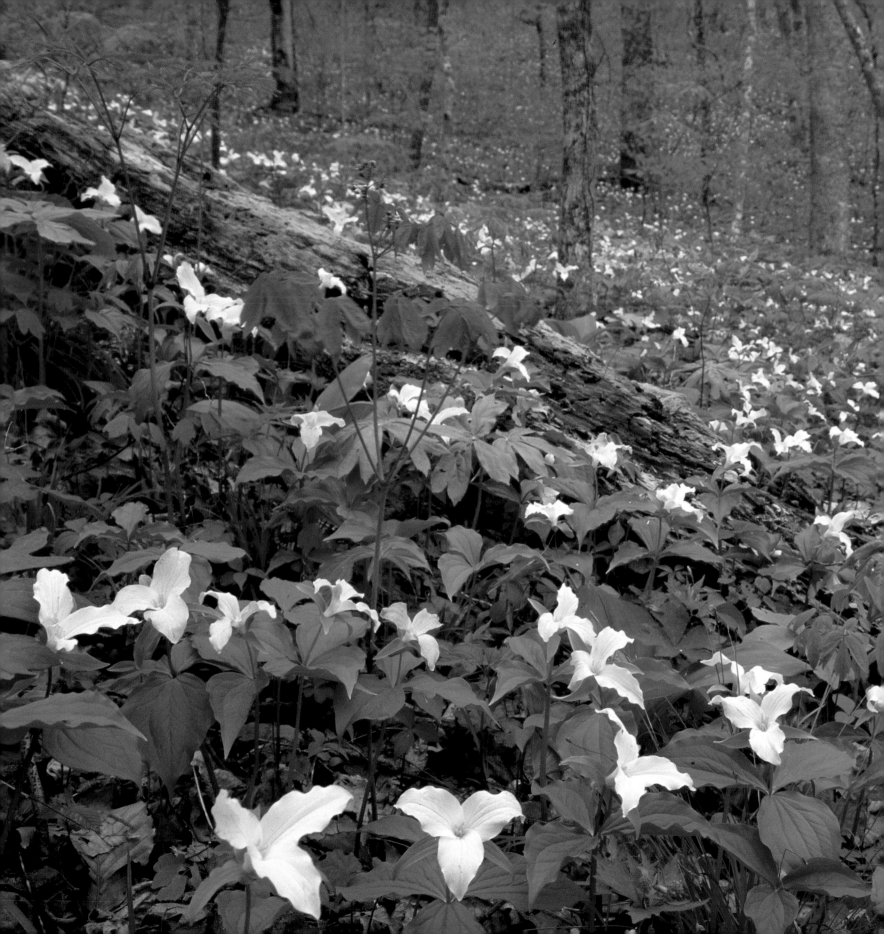

Hugh Nourse & Carol Nourse

Wildflowers *of* Georgia

THE UNIVERSITY OF GEORGIA PRESS | ATHENS & LONDON

© 2000 by the University of Georgia Press

Athens, Georgia 30602

All rights reserved

Designed by Kathi Dailey Morgan

Set in Garamond Monotype by G&S Typesetters

Printed and bound by C&C Offset

The paper in this book meets the guidelines for

permanence and durability of the Committee on

Production Guidelines for Book Longevity of the

Council on Library Resources.

Printed in Hong Kong

04 03 02 01 00 C 5 4 3 2 1

Frontispiece: LARGE-FLOWERED TRILLIUM

(*Trillium grandiflorum*) Rabun County, April 21

Library of Congress Cataloging-in-Publication Data

Nourse, Hugh O.

 Wildflowers of Georgia

 by Hugh Nourse and Carol Nourse.

 p. cm.

 ISBN 0-8203-2179-6 (alk. paper)

 1. Photography of plants—Georgia.

 2. Wild flowers—Georgia—Pictorial works.

 I. Nourse, Carol, 1933– . II. Title.

TR724.N68 2000

779'.34'09758—DC21 99-16493

British Library Cataloging-in-Publication Data available

Contents

Preface

Our romance with Georgia's wildflowers began with our attraction to the Appalachian Trail. As longtime walkers transplanted from the Midwest, we found the two thousand–mile mountain footpath a powerful lure. From our home in Athens, we began day-hiking short segments of the Georgia portion of the trail and dreamed of someday attempting to walk the whole distance. While hiking, we soon discovered that the trail's nickname, "the long green tunnel," is well deserved. Enclosed by trees and shrubs, the Appalachian Trail offers scenic vistas only occasionally. As a result, our eyes were attracted instead by the flowers beside the path, charmers with names like trout lily, harebell, and windflower, jewelweed, Jack-in-the-pulpit, and cardinal flower. How could we resist their beauty?

For susceptible people, wildflowers can become an addiction that produces strange symptoms. In our case the first sign was our accumulation of wildflower field guides and identification keys. Then we began to take photographs of wildflowers, to attend camera workshops and photography groups, and to buy more photography equipment. Next we joined the Georgia Botanical Society in order to go on their field trips throughout the state. We brought home native plants from local nurseries and even tried raising some from seed.

As we came to appreciate the variety and beauty of Georgia's native flowers, we also came to realize how fragile and threatened the remaining natural areas of Georgia are. In the few hundred years since the arrival of European settlers, the landscape has been so changed by human activities such as agriculture, pine plantations, and the building of roads, dams, houses, and other structures that few natural wild plant communities remain. As the plants' habitats shrink, more and more species are threatened with extinction.

When plants become extinct, it is not just their beauty we miss. Natural plant communities are a part of our basic life-support system. They provide oxygen and remove carbon dioxide from the air, protect our watersheds by absorbing rainfall and by filtering out pollutants, and serve as potential sources of medicines, fibers, and food, to name just a few of their vital functions. Therefore, when our native plant communities are in trouble we are all in trouble.

There are still some wild places remaining in Georgia, and there are many groups and individuals who are working to protect and restore them. Through the Georgia 2000 and Rivers 2000 programs, the state has set aside several areas for native plant communities. Many conservation groups are working to acquire or protect critical habitats, and schoolchildren are learning how to grow wildflowers and build pitcherplant bogs. Individuals participate in plant rescues or write letters to legislators and newspaper editors to increase awareness of this important issue. We hope this book will express our profound thanks to all those who have helped to protect Georgia's wildflowers and their habitats and that others will be inspired to join them in the fight to save our natural heritage.

Acknowledgments

WE WOULD LIKE TO acknowledge the assistance of many people. Lee Reed started us on the path to writing this book by inviting us to participate in the Athens Photography Sharegroup. Les Saucier, mentor exemplar, taught us how to improve our work and how to evaluate our slides critically. By showing us their photographs each month, the other members of the Athens Photography Sharegroup kept us humble and inspired us to do better work.

The field trip leaders for the Georgia Botanical Society taught us how to identify plants, how to read botanical keys, and where to find beautiful and unusual flowers. Among these great volunteers, we would especially like to recognize Jim Allison, Steve Bowling, David Emory, Tom Patrick, Scott Ranger, Frankie Snow, James Sullivan, Keith Tassin, and Richard Ware. Our thanks also for the great camaraderie of Bot Soccers on field trips and other outings.

Jennifer Ceska of the State Botanical Garden of Georgia provided encouragement as well as information on conservation efforts and location and bloom times for photogenic or unusual plants.

Thanks to all!

Introduction

ON A CRISP May morning we are photographing wake robin, a red trillium growing beside the trail at Black Rock Mountain State Park. Our camera sits atop a tripod, which is spread out flat on the ground. A collapsible white umbrella shields the flower from a persistent breeze. Hugh kneels and peers through the lens, waiting for a moment of complete stillness to press the shutter release. A young man passing by stops to see what we are photographing, but he seems unimpressed. "Do you ever see any deer along here?" he asks us. Then a family approaches from the opposite direction. The two little boys bounce past, observing us as they would any other obstruction in the trail, while their parents cast us a bemused glance as they hurry to keep up with them.

The breeze stops momentarily, and Hugh takes the photograph. As we are packing up our camera equipment, a middle-aged man and woman come along. "Photographing flowers, are you?" they ask. "There's a great bunch of showy orchis just around the next bend." Ah, how great to meet fellow wildflower addicts!

We photograph wildflowers because they are beautiful, of course. But garden flowers are beautiful, too, and often showier because they are bred to be spectacular. What makes wildflowers special is the excitement of the hunt. Their blooming times vary from year to year, depending on the

weather. In some years a particular species may bloom profusely, while in others it may be sparse. Sometimes a plant is eaten by deer just before the buds open. And then there are photographic requirements to consider. Will the light be so dim that very long exposures are needed? Will the forest be filled with bright splotchy light impossible to record properly on color film? Will it rain so hard that we can't photograph because the camera's electronic functions might be damaged? All of this adds to the uncertainty we experience in traveling halfway across Georgia to photograph a particular wildflower species and to the thrill we feel when we actually accomplish our mission.

This book is a photographic celebration of the diversity and beauty of Georgia's wildflowers. It is not a systematic treatment; these are just some of the best photographs we have made during our eight-year odyssey around the state. Our purpose in this book is to inspire you to enjoy, respect, and conserve our wildflowers and to celebrate the wonder of their beauty.

Physiographic Regions

The wildflowers we present in this book are found in many parts of Georgia. Because the differences in underlying rock and climate affect which wildflowers can be found in the various areas, we have divided the state into four physiographic regions: Blue Ridge Mountains; Cumberland Plateau, Ridge, and Valley; Piedmont; and Coastal Plain.

The Blue Ridge Mountains include Brasstown Bald, which, at an elevation of 4,784 feet, is the highest point in Georgia. This region covers the northeastern part of the state and almost forms a V, with Amicalola

Falls State Park forming the point. The underlying rock in this area is metamorphic and the soils are acidic, so many members of the heath family thrive in this environment.

The Cumberland Plateau, Ridge, and Valley region includes the northwestern part of the state. To the east, U.S. Highway 411 provides a good boundary, with the southern boundary being just south of Cedartown. The underlying rock of this region is sedimentary limestone and sandstone; plants that like calcium occur more often in the limestone areas of this region. Many plants found here also grow in the sedimentary areas of the Midwest.

The Piedmont, literally the "foot of the mountain," includes the rolling hills between the two previous regions and the fall line. This line, which runs approximately from Columbus to Macon to Augusta, marks a change from higher to lower elevations and from a predominantly red clay to sandy soil.

The Coastal Plain comprises the rest of the state below the fall line, land which was created from the former continental shelf and from beaches and dunes.

Although a photograph of a particular flower is included in one region's section of the book, some species, such as bloodroot (*Sanguinaria canadensis*) and yellow fringed orchid (*Platanthera ciliaris*) grow in all four, while others are concentrated in only one. For example, elf-orpine (*Diamorpha smallii*) and Puck's orpine (*Sedum pusillum*) are found only on granitic outcrops in the Piedmont, and hooded pitcherplant (*Sarracenia minor*) and trumpets (*Sarracenia flava*) are found only in the Coastal Plain. Michigan lily (*Lilium michiganense*) and celandine poppy (*Stylophorum diphyllum*) are found only in the Cumberland Plateau, Ridge, and Valley, while

fringed gentian (*Gentianopsis crinita*) is found only in the Blue Ridge. Other species can be found in two or three of these regions.

In each regional division in this book we discuss places to see spectacular wildflower displays. Descriptions for almost all of the trails we mention can be found in Donald W. Pfitzer's *The Hiker's Guide to Georgia* (Helena, MT: Falcon Press, 1993). The trails we mention are all well marked and are on public lands. However, our photographs were not all taken on these trails; some were taken by special arrangement in areas that are not open to the public.

Bloom Times

In order to give the reader some idea of the bloom times for each wildflower, we have provided the month and day when the photograph of each plant was taken and the approximate location. As we noted before, however, bloom times vary from year to year, and they also vary from place to place depending on latitude, elevation, and other factors. Some plants might bloom several weeks before the date listed in the photograph's caption, and in some years they can be found several weeks after the date. Readers should therefore take into account that the dates given indicate only approximate bloom times for that location.

Plant Identification

For the beginning botanist there are several good field guides to consult. We started with *Wildflowers of the Southeastern United States* (Athens: University of Georgia Press, 1975) by Wilbur H. Duncan and Leonard E. Foote, which is now out of print. A new version, *Wildflowers of the Eastern United States* by Wilbur and Marion Duncan, is now available from the University of Georgia Press.

So far there is no manual that covers in detail all of the plants found in Georgia. Our primary reference for the common and scientific names for the wildflowers of the area above the fall line is B. Eugene Wofford, *Guide to the Vascular Plants of the Blue Ridge* (Athens: University of Georgia Press, 1989). For information on the flowers of the Coastal Plain we used Richard P. Wunderlin, *A Guide to the Vascular Plants of Florida* (Tallahassee: University Press of Florida, 1998). For prairie-type plants located in the Cumberland Plateau, Ridge, and Valley region Doug Ladd and Frank Oberle's *Tallgrass Prairie Wildflowers* (Helena, MT: Falcon Press, 1995) has proved quite useful. For the protected plants of Georgia our main reference was Thomas S. Patrick, James R. Allison, and Gregory A. Krakow, *Protected Plants of Georgia* (Georgia Department of Natural Resources, Wildlife Resources Division, Georgia Natural Heritage Program, 1995).

Protected Plants

We have noted the few flowers in this collection that are currently protected in Georgia. These plants are protected only on public land. Some

plants are truly rare and almost extinct, but that is not the only reason for protection. Flowers like lady's slipper orchids and pitcherplants are protected because they are too popular. They are disappearing from the wild because people dig them up for their own gardens or for sale. Ironically, because microorganisms vital to the growth of these plants are often not present in the soils of household gardens, flowers like lady's slipper orchids may not survive transplanting from their native sites. They are protected so that we may continue to enjoy them.

Photographic Notes

For photographing wildflowers, the two books most useful to us have been Craig and Nadine Blacklock, *Photographing Wildflowers: Techniques for the Advanced Amateur and Professional* (Stillwater, MN: Voyageur Press, 1987) and Allen Rokach and Anne Millman, *The Field Guide to Photographing Flowers* (New York: Amphoto, 1995).

The images in this book were all made using Nikon cameras: the FM2N, N8008s, and F4. Nikon lenses used were 28mm, 24–50mm zoom, 55mm micro, 105mm micro, 75–300mm zoom, and 200mm micro. The photographs by Hugh were taken primarily with the 105mm micro, while most of Carol's pictures were taken with the 24–50mm zoom. A circular polarizing filter and a warming filter (Nikon A2) were used when needed, and on some occasions a Nikon SB25 Speedlight was used off-camera as a fill-flash. Our favorite film for color saturation, contrast (especially on a cloudy day), and fine grain is Fujichrome Velvia rated at ASA 50. However, some of the photos were made using Ektachrome E100SW.

The most important accessory we used while photographing wild-flowers was a tripod because it prevented camera shake at slow shutter speeds. Slow shutter speeds were necessary because we used fine-grained film in low-light conditions and needed small apertures for reasonable depth of field at high magnifications. In the past we used Bogen tripods, but we now utilize the Gitzo Mountaineer exclusively because of its light weight.

Overleaf:
SHOALS SPIDERLILY
(*Hymenocallis coronaria*),
a Georgia protected plant
Lincoln County, May 28

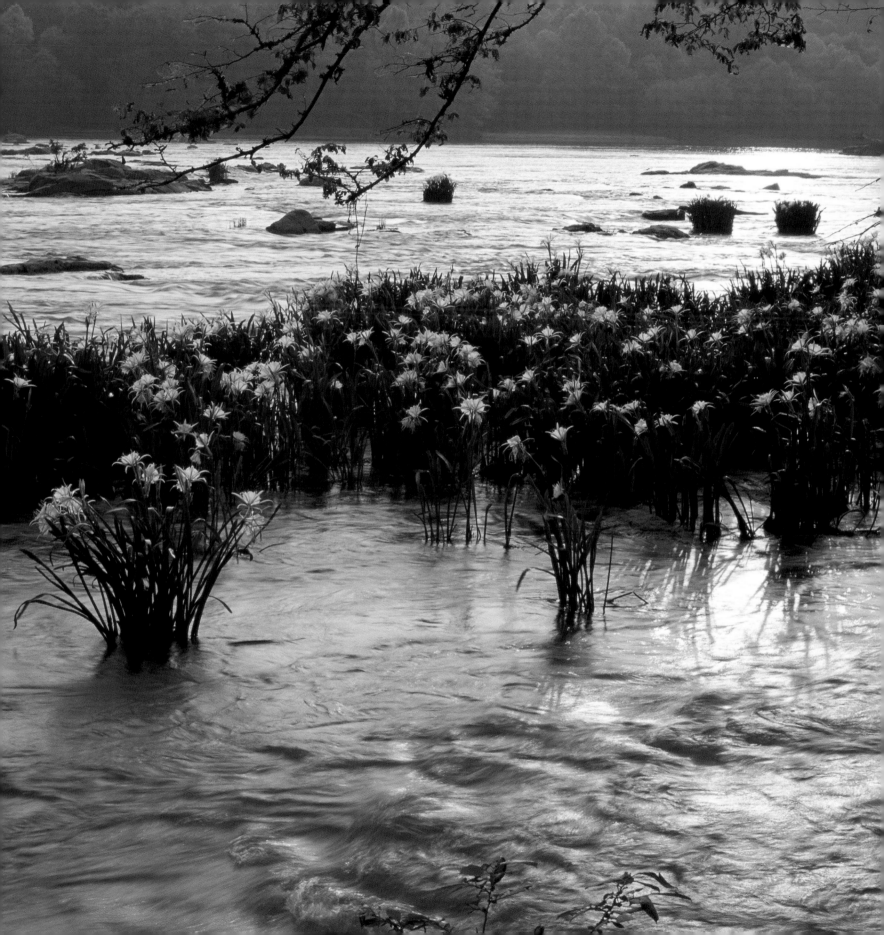

Piedmont

A T THE BEGINNING of each year we haunt the Orange Trail at the State Botanical Garden of Georgia in Athens on a weekly basis to check for blooming wildflowers. As early as the first of January we have found beautiful hepaticas (*Hepatica nobilis* var. *obtusa*), but nothing further happens until mid-February, when rue anemone (*Thalictrum thalictroides*) begins to flower. By March or April new plants such as wild geranium (*Geranium maculatum*) and May apple (*Podophyllum peltatum*) begin to blossom. All of these early spring ephemerals hurry to bloom and soak up enough energy before the leaves in the upper canopy fill in, shading them until fall and cutting off their access to vital sunlight.

In February and March one can find trout lilies (*Erythronium umbilicatum*) at Indian Springs State Park (Flovilla, GA), where they grow nestled among the buttressing roots of large beech trees, which are wonderful backgrounds for photography. At Panther Creek Trail (Turnerville, GA) in the Chattahoochee National Forest one can see green-and-gold (*Chrysogonum virginianum*), purple toadshade (*Trillium cuneatum*), bellwort (*Uvularia puberula*), and wood anemone (*Anemone quinquefolia*) in late March and April. Other flowers bloom along the trail throughout the summer and fall.

Other places to look for flowers in the Piedmont region in Georgia include Kennesaw Mountain National Battlefield Park in Marietta, Sweetwater Creek Conservation Park in Lithia Springs, and the Chattahoochee National Recreation Area in Atlanta (West Palisades Section). The State Botanical Garden includes the Dunson Native Flora Garden, which displays wildflowers from all over the state in a naturalistic setting. Two other

gardens, the Atlanta Botanical Garden and Callaway Gardens in Pine Mountain, also have wildflower trails and displays.

Because the original forests were cut down for agriculture many years ago, there are few undisturbed forest areas left in the Piedmont. Fernbank Science Center in Atlanta preserves some of the original forest, but nearly everywhere else we see the results of plant succession, as second-, third-, or later-generation forests occupy the natural areas.

Granitic outcrops, such as the monadnock Stone Mountain, are one other type of natural habitat that can still be found in the Georgia Piedmont. Many rare and unusual plants grow in these harsh environments. In spring elf-orpine (*Diamorpha smallii*), sandwort (*Arenaria uniflora*), Puck's orpine (*Sedum pusillum*), and groundsel (*Senecio tomentosus*) bloom in depressions on these outcrops starting around April 15. In fall the Stone Mountain daisy (*Helianthus porteri*) blooms en masse between September 15 and October 15. However, since outcrops are sources of rock for roads and for industry in Georgia, a number of outstanding granitic rock plant communities have been destroyed by quarrying.

To see those wildflowers that commonly grow on granitic outcrops, one can visit Stone Mountain, Arabia Mountain (Lithonia, GA), or Panola Mountain (Stockbridge, GA), which are all open to the public. In addition, the Nature Conservancy has preserved two granitic outcrops in Georgia: Camp Meeting Rock and Heggies Rock. Contact the Georgia Office of the Nature Conservancy in Atlanta for access.

On Piedmont roadsides, native wildflowers can be seen growing among the grasses. Particularly striking are bright orange butterfly weed (*Asclepias tuberosa*) in early summer and swathes of goldenrod (*Solidago* spp.) in the fall.

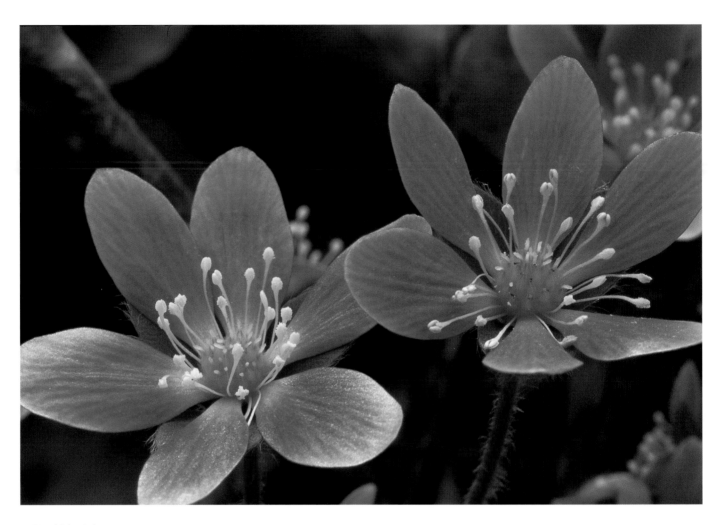

HEPATICA

(*Hepatica nobilis* var. *obtusa*)

Orange Trail, State Botanical

Garden of Georgia, February 20

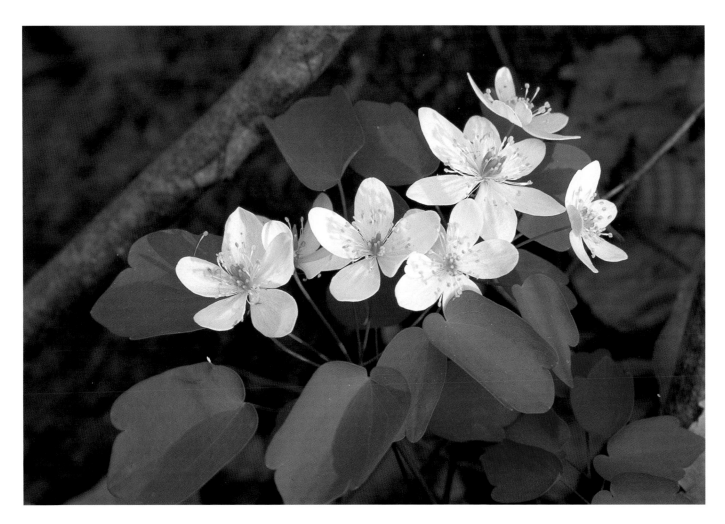

RUE ANEMONE
(*Thalictrum thalictroides*)
Orange Trail, State Botanical
Garden of Georgia, March 23

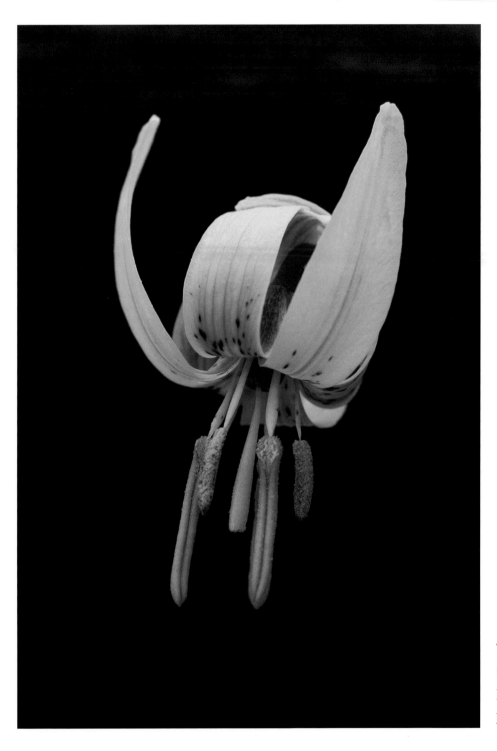

TROUT LILY
(*Erythronium umbilicatum*)
Indian Springs State Park,
March 11

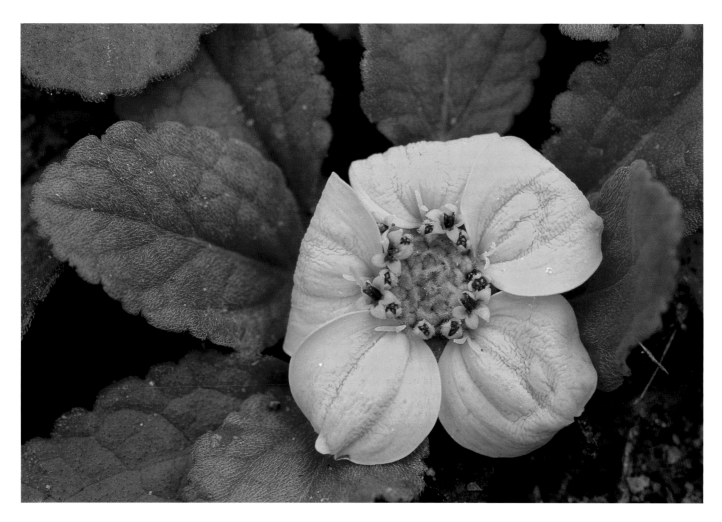

GREEN-AND-GOLD
(*Chrysogonum virginianum*)
Panther Creek Trail, April 3

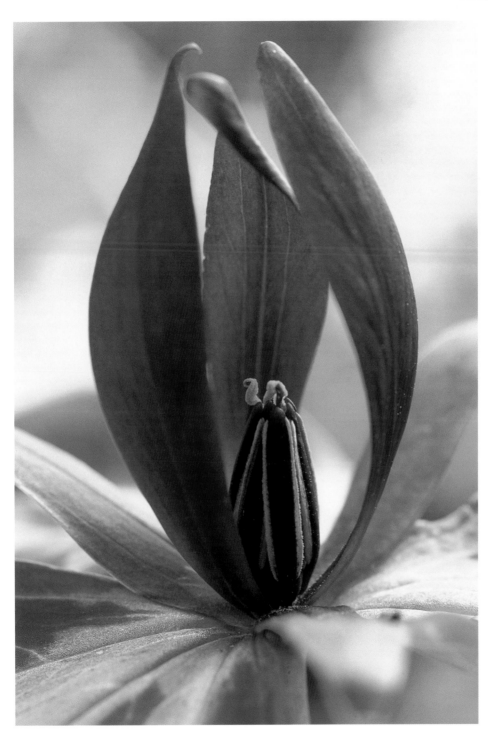

PURPLE TOADSHADE
(*Trillium cuneatum*)
Panther Creek Trail, April 4

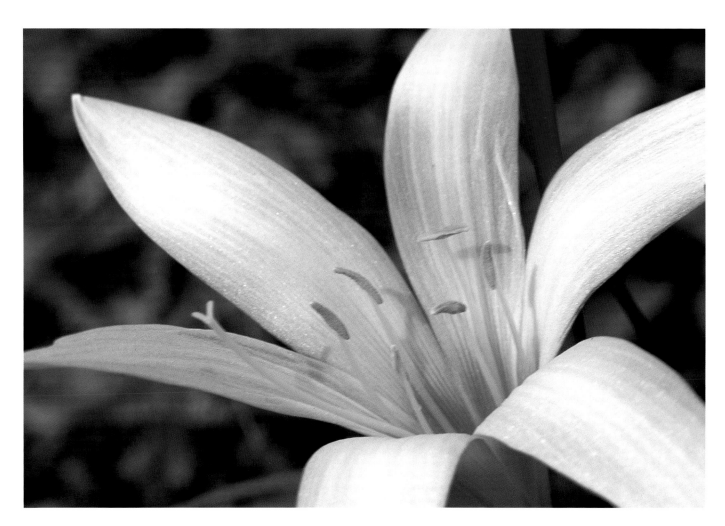

ATAMASCO LILY
(*Zephyranthes atamasco*)
Jasper County, April 4

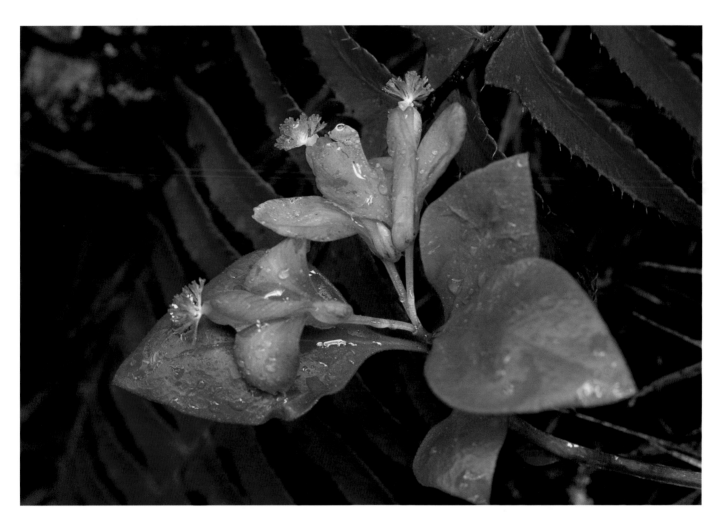

GAY WINGS

(*Polygala paucifolia*)

Panther Creek Trail, April 20

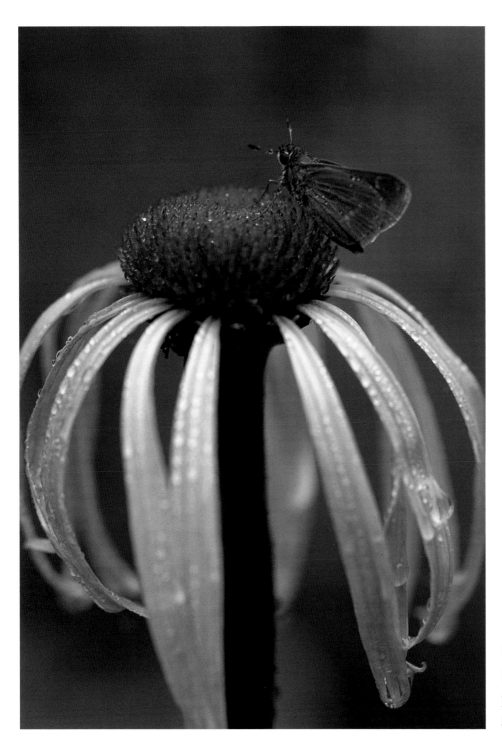

SMOOTH PURPLE CONEFLOWER
(*Echinacea laevigata*), a Georgia
protected plant
Stephens County, May 25

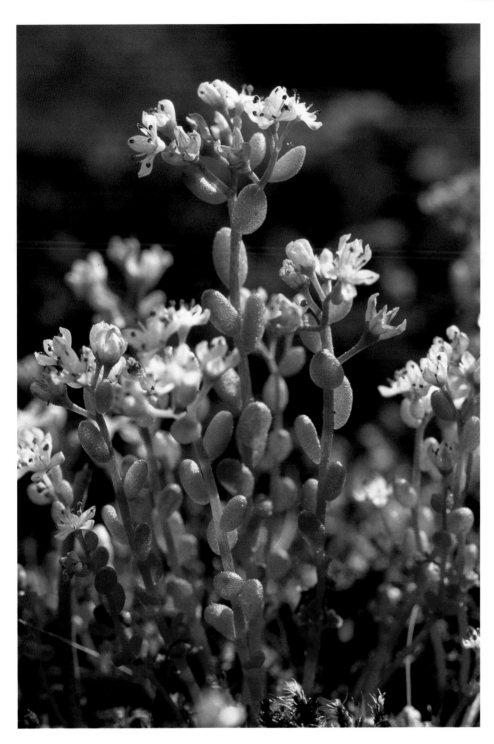

ELF-ORPINE

(*Diamorpha smallii*)

Clarke County, April 15

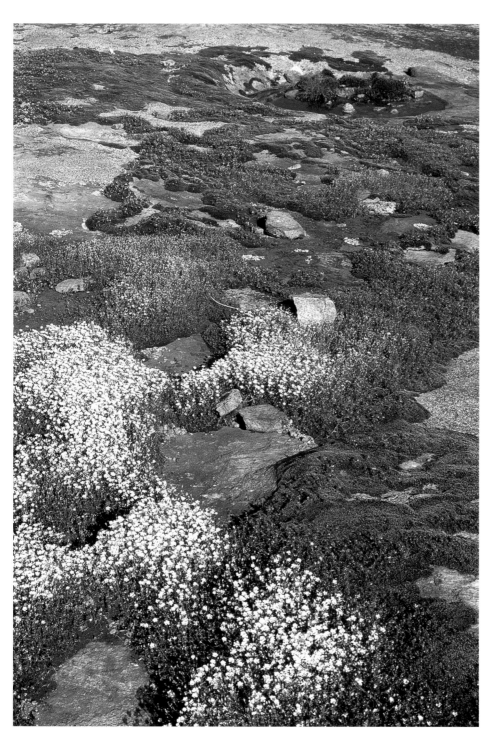

SANDWORT
(*Arenaria uniflora*) and
ELF-ORPINE
(*Diamorpha smallii*)
Arabia Mountain, April 5

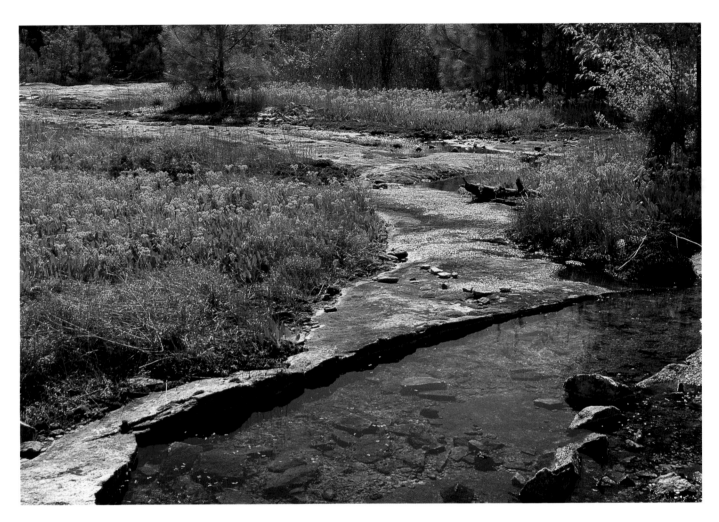

GROUNDSEL

(*Senecio tomentosus*)

Arabia Mountain, April 5

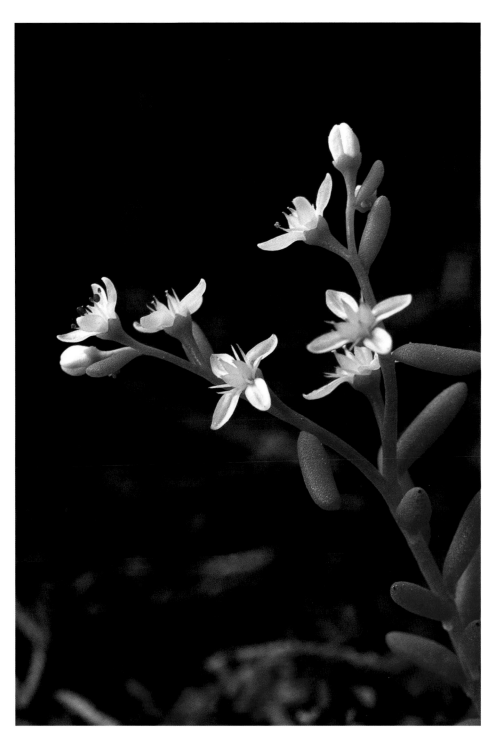

PUCK'S ORPINE
(*Sedum pusillum*),
a Georgia protected plant
Clarke County, April 5

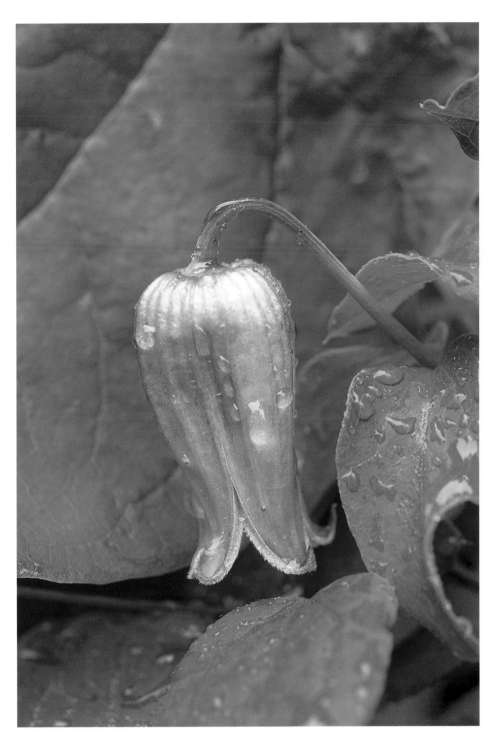

CLEMATIS

(*Clematis crispa*)

Stephens County, May 25

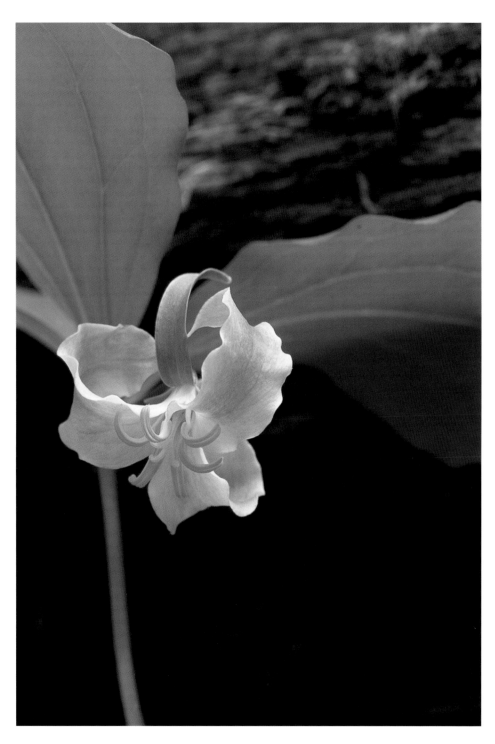

CATESBY'S TRILLIUM
(*Trillium catesbaei*)
Panther Creek Trail, May 9

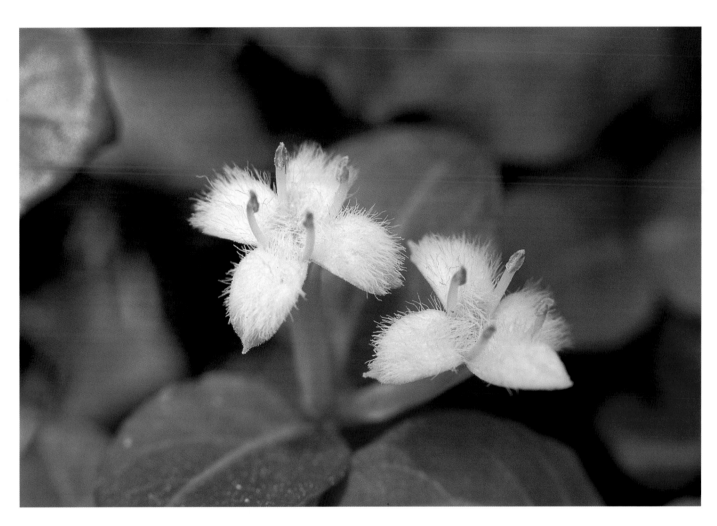

PARTRIDGE BERRY

(*Mitchella repens*)

Panther Creek Trail, May 23

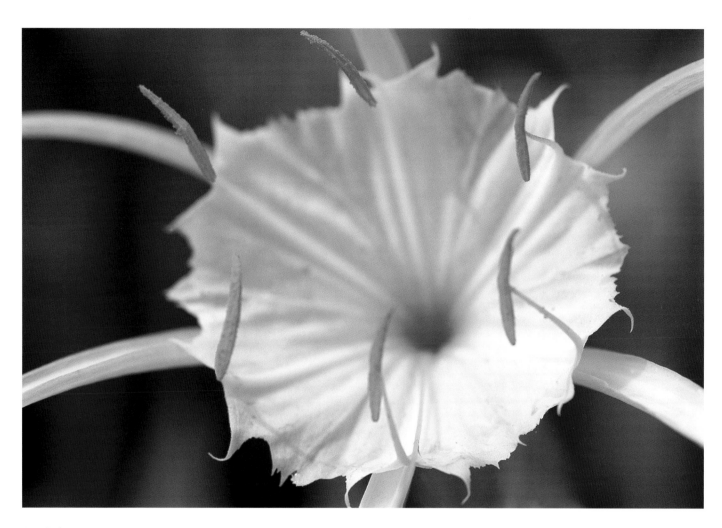

SHOALS SPIDERLILY
(*Hymenocallis coronaria*),
a Georgia protected plant
Lincoln County, May 28

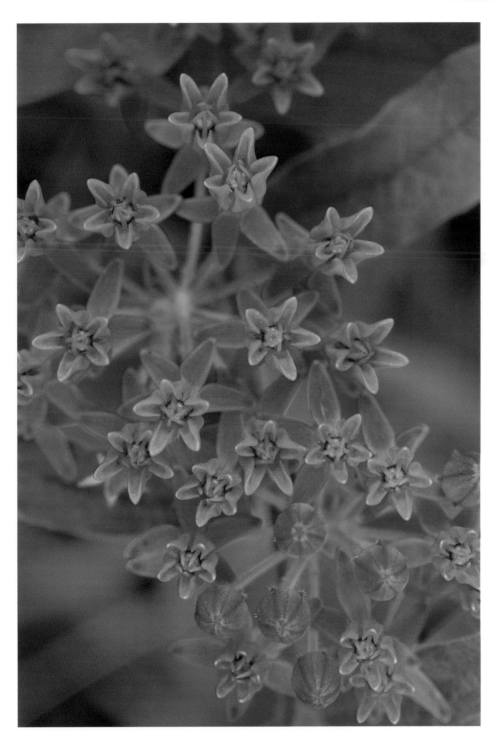

BUTTERFLY WEED
(*Asclepias tuberosa*)
undeveloped area, State Botanical
Garden of Georgia, June 4

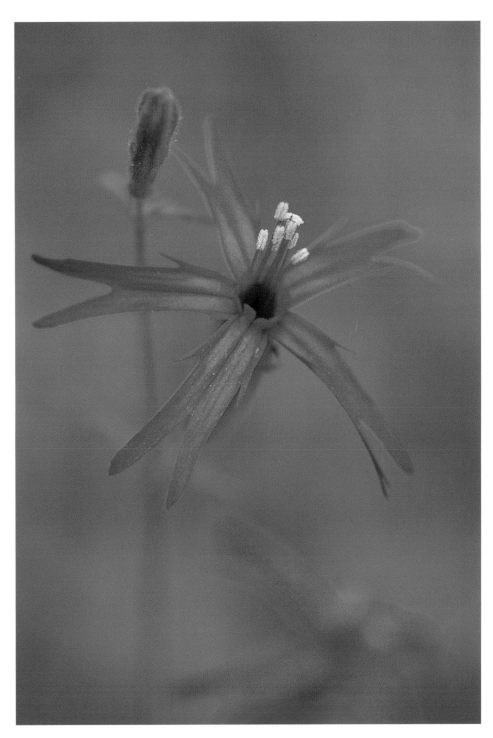

FIRE PINK

(*Silene virginica*)

Panther Creek Trail, June 5

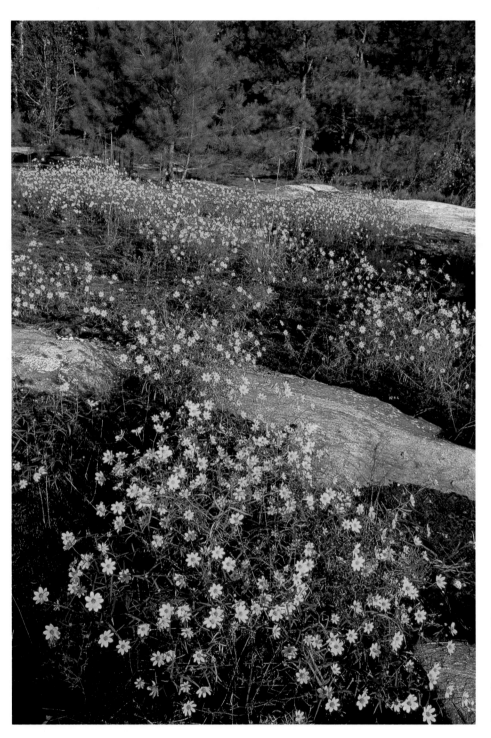

STONE MOUNTAIN DAISY
(*Helianthus porteri,* formerly
Viguiera porteri)
Thompson Mill Arboretum,
September 14

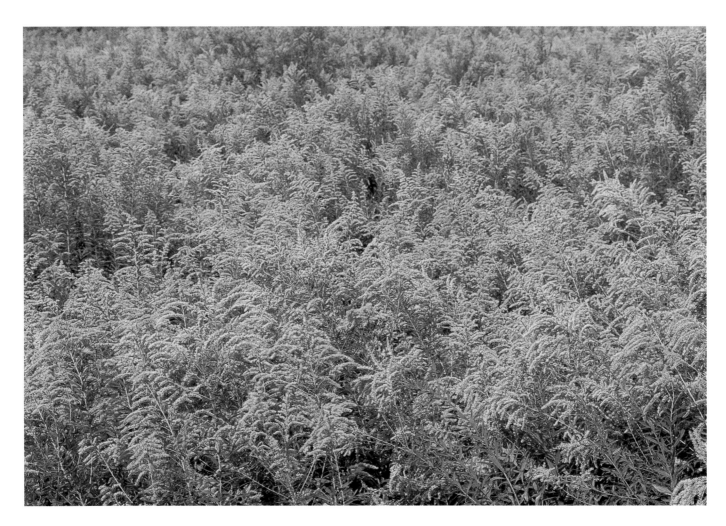

GOLDENROD
(*Solidago canadensis*)
Jackson County, September 25

Overleaf:
GOLDENCLUB
(*Orontium aquaticum*)
Okefenokee National Wildlife Refuge, March 1

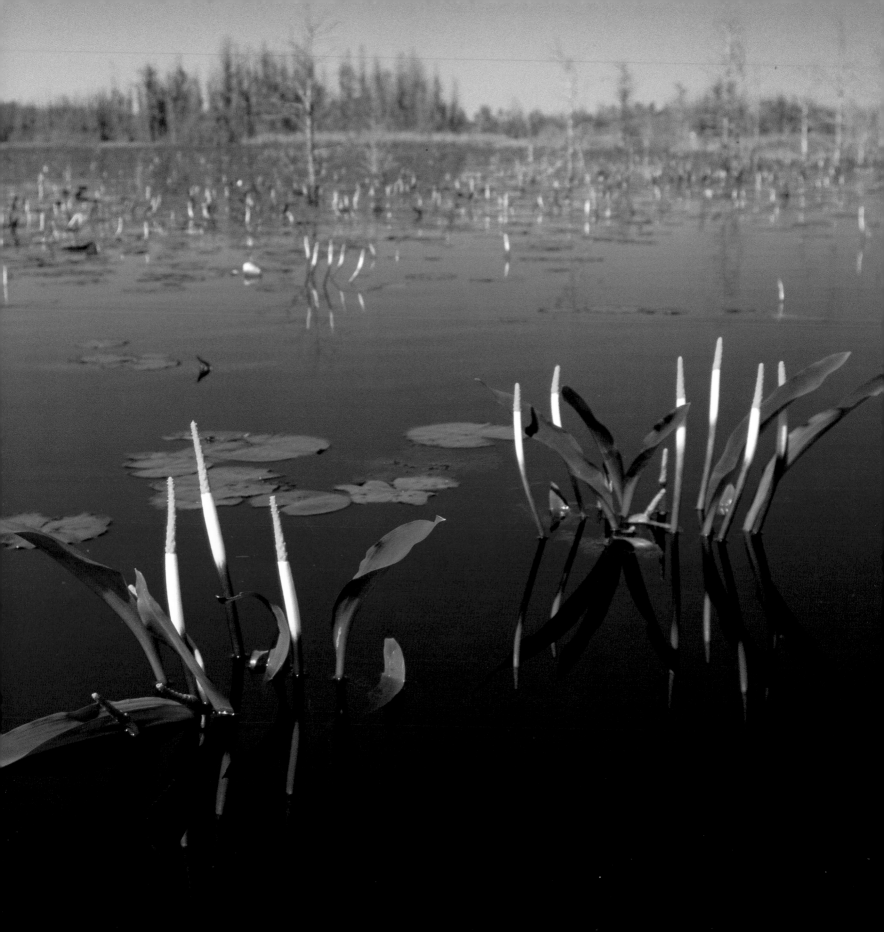

Coastal Plain

BEING AVID mountain hikers, we neglected the Coastal Plain for many years but later found that to be a mistake. We have discovered some of the most exquisite plants there. One of the best places to visit is the Okefenokee National Wildlife Refuge (Folkston, GA). Taking a canoe trip into the Grand Prairie in early March will allow you to see goldenclub (*Orontium aquaticum*) blooming in profusion. In May pitcherplants and orchids grow in the ditches along the road to the boardwalk to Chesser Prairie. In spring pitcherplants, as well as other wetland plants, can be seen from the boardwalk.

Once upon a time much of the Coastal Plain was a longleaf pine–wiregrass habitat, maintained by periodic natural fires. In this habitat, pitcherplants flourished in the wetland areas. Today only a few large areas of this habitat survive, most having been eliminated for agriculture and pine plantations. Fires have been surpressed, and bogs drained for these pursuits. As a result there are few places where one can find even remnant pitcherplant bogs. A small pitcherplant bog has been revived by controlled burning at General Coffee State Park (Nicholls, GA) where one might see hooded pitcher plant (*Sarracenia minor*), trumpets (*Sarracenia flava*), grassleaf Barbara's buttons (*Marshallia tenuifolia*), and white fringed orchid (*Platanthera blephariglottis*). Although the bog is small, it is one of the few public places where one can wander through such a habitat.

Another place one can see a pitcherplant bog is at Reed Bingham

State Park (Adel, GA). A boardwalk that will run through the bog is scheduled to be built during the year 2000. Other pitcherplant bogs in the region are located either on private property or in conservation areas and are therefore not open to the public.

Providence Canyon State Park (Lumpkin, GA) is home to the July-blooming native plumleaf azalea (*Rhododendron prunifolium*), which is a Georgia protected plant. Another protected plant, the Georgia plume (*Elliottia racemosa*), blossoms in June in the Big Hammock Natural Area (Glennville, GA).

Broxton Rocks, a Nature Conservancy Preserve, is an unusual natural habitat on the Altamaha Grit, a sandstone outcrop running through the Coastal Plain. Broxton Rocks protects a longleaf pine–wiregrass community. Among the beautiful wildflowers located here are the greenfly orchid (*Epidendrum conopseum*) and the cutleaf beardtongue (*Penstemon dissectus*), both Georgia protected plants. Periodic burning is being applied by the Nature Conservancy to return the area to a possible former state—even including a pitcherplant bog. The Nature Conservancy opens the preserve for walks four times a year; their Atlanta office schedules the dates for public access.

Keeping an eye on the roadside ditches throughout the Coastal Plain can be very productive for those on the lookout for wildflowers. Once while searching back roads for a place to photograph a sunset on Lake Seminole, we discovered Coastalplain balm (*Dicerandra linearifolia*) along the road. We had never seen it before. Pitcherplants, American white water lily (*Nymphaea odorata*), atamasco lily (*Zephyranthes atamasco*), and yellow butterwort (*Pinguicula lutea*) can often be found in ditches in this area.

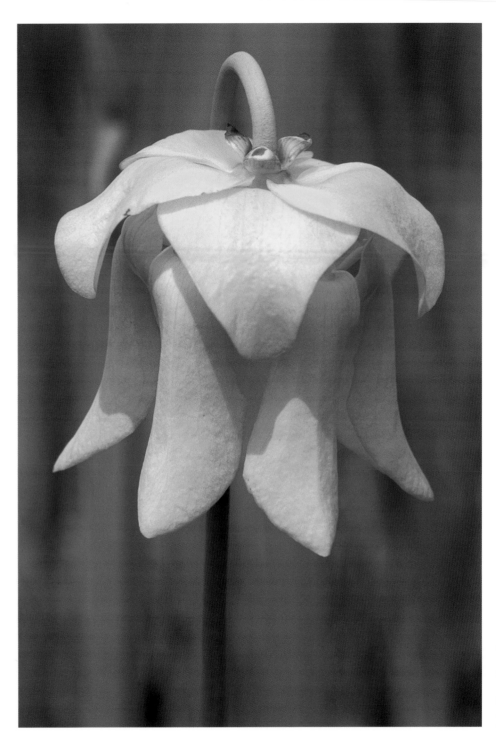

TRUMPETS
(*Sarracenia flava*),
a Georgia protected plant
Brooks County, April 18

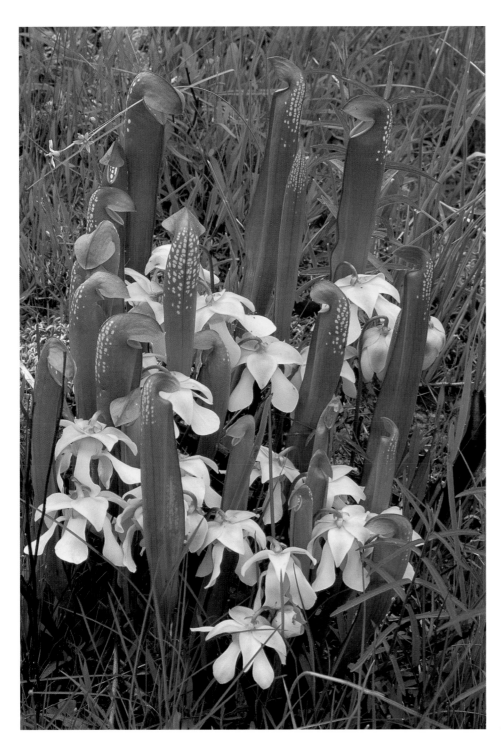

HOODED PITCHERPLANT
(*Sarracenia minor*),
a Georgia protected plant
General Coffee State Park,
April 11

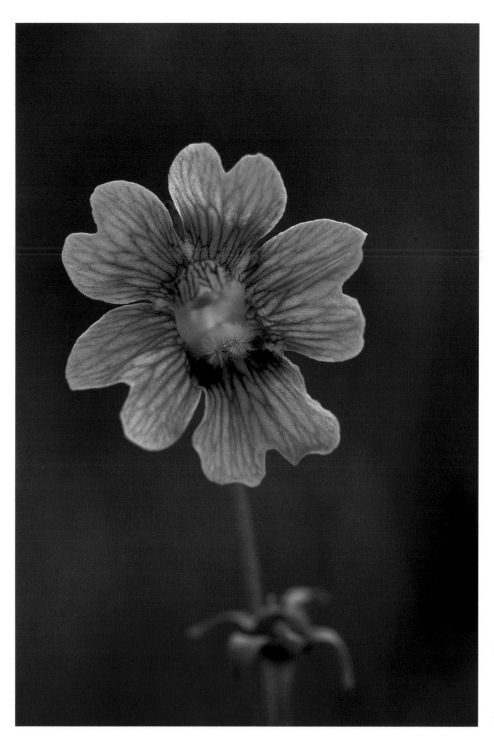

BLUE BUTTERWORT
(*Pinguicula caerulea*),
a yellow variant
Brooks County, April 18

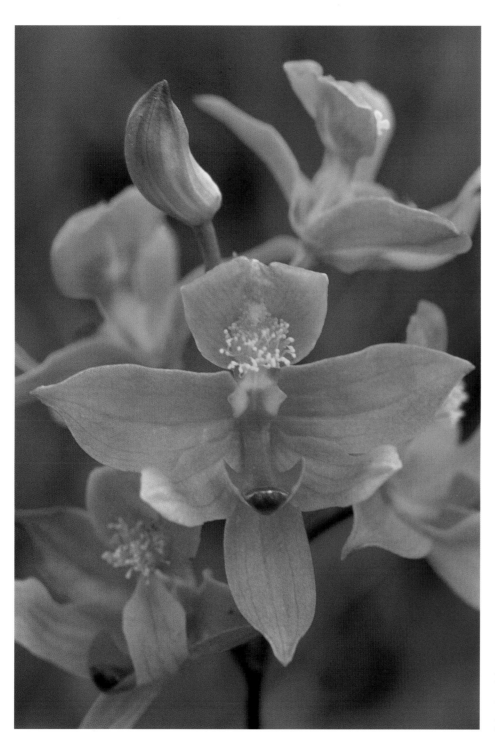

BEARDED GRASSPINK
(*Calopogon barbatus*)
Brooks County, April 18

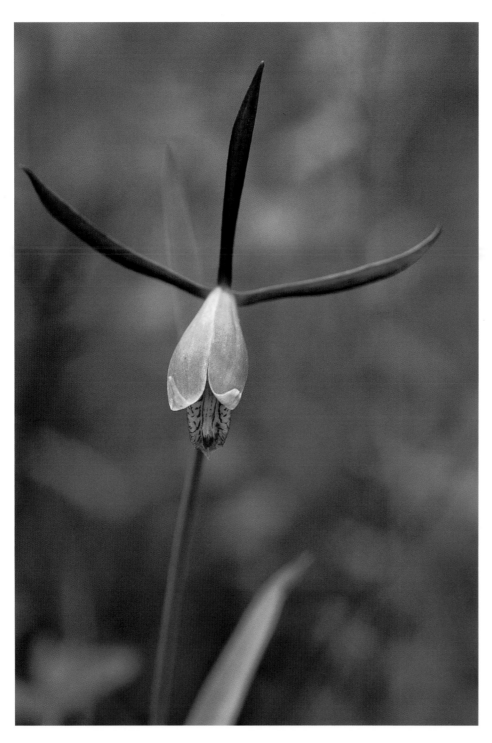

ROSEBUD ORCHID
(*Pogonia divaricata*)
Colquitt County, May 10

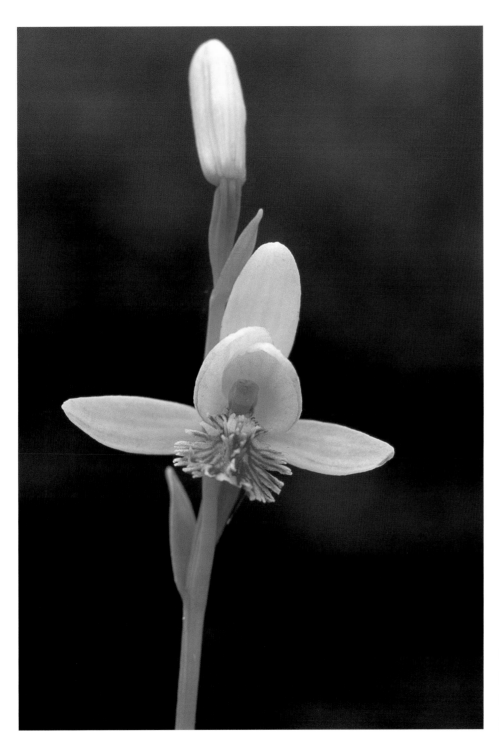

ROSE POGONIA
(*Pogonia ophioglossoides*)
Okefenokee National Wildlife
Refuge, May 16

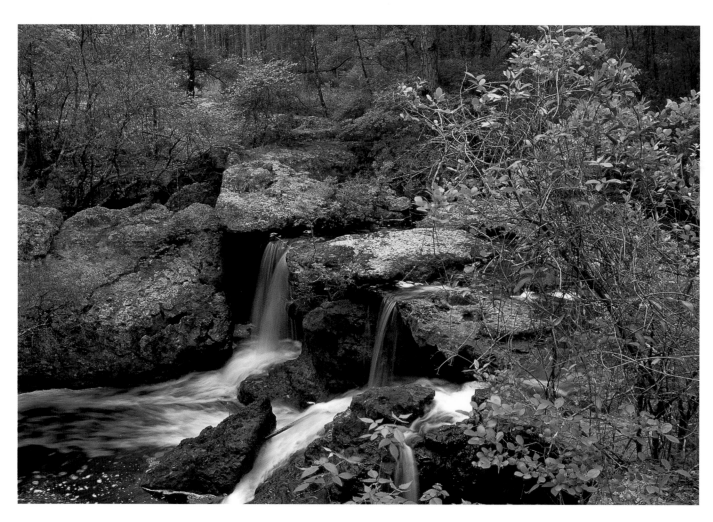

CROSSVINE

(*Bignonia capreolata*)

Broxton Rocks, April 19

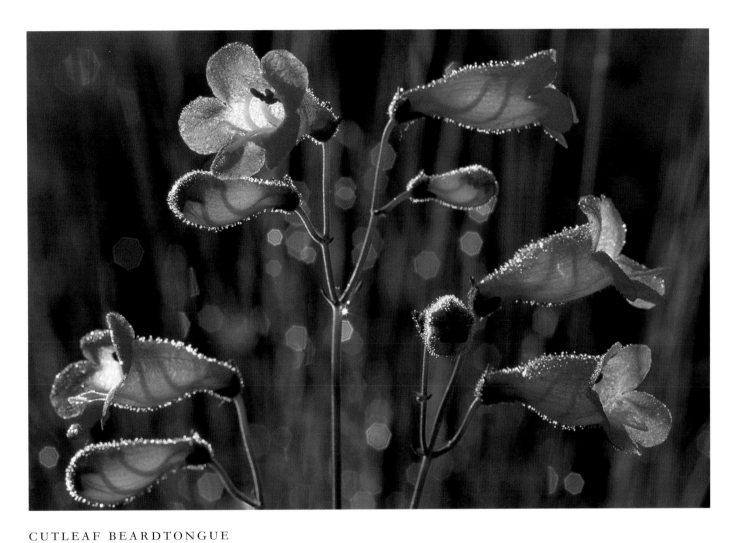

CUTLEAF BEARDTONGUE

(*Penstemon dissectus*),

a Georgia protected plant

Broxton Rocks, May 5

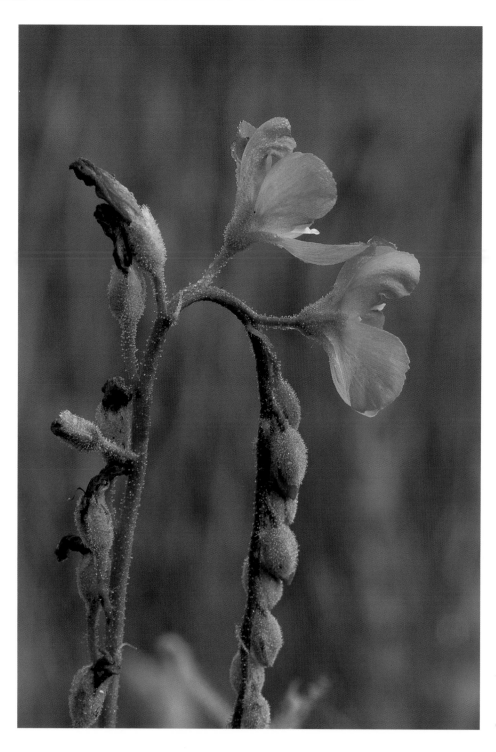

TRACY'S SUNDEW
(*Drosera tracyi*)
Colquitt County, May 20

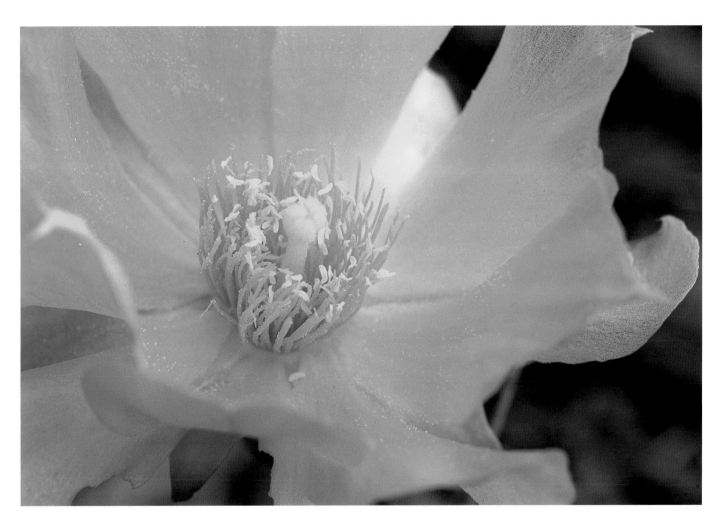

PRICKLYPEAR
(*Opuntia humifusa*)
Long County, May 17

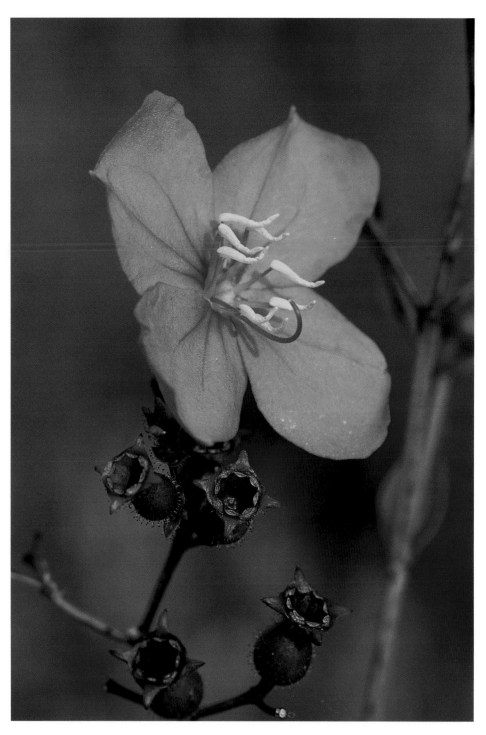

SAVANNAH MEADOW BEAUTY
(*Rhexia alifanus*)
Brantley County, July 11

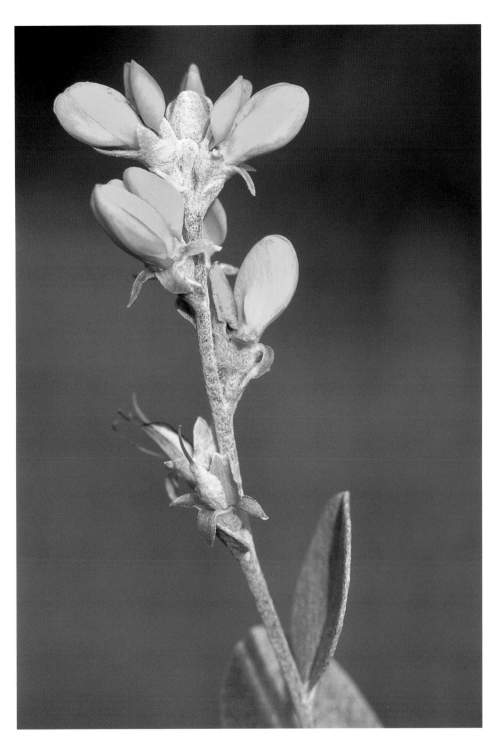

HAIRY RATTLEWEED
(*Baptisia arachnifera*),
a Georgia protected plant
Brantley County, July 11

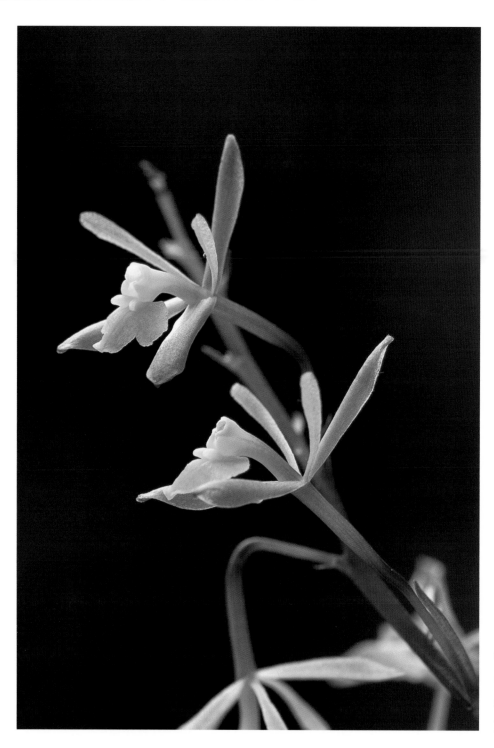

GREENFLY ORCHID
(*Epidendrum conopseum*),
a Georgia protected plant
Broxton Rocks, July 7

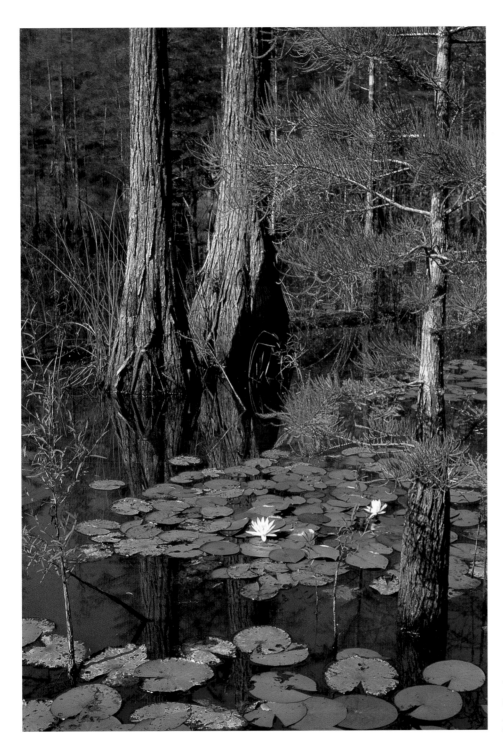

AMERICAN WHITE WATERLILY
(*Nymphaea odorata*)
Dooly County, August 4

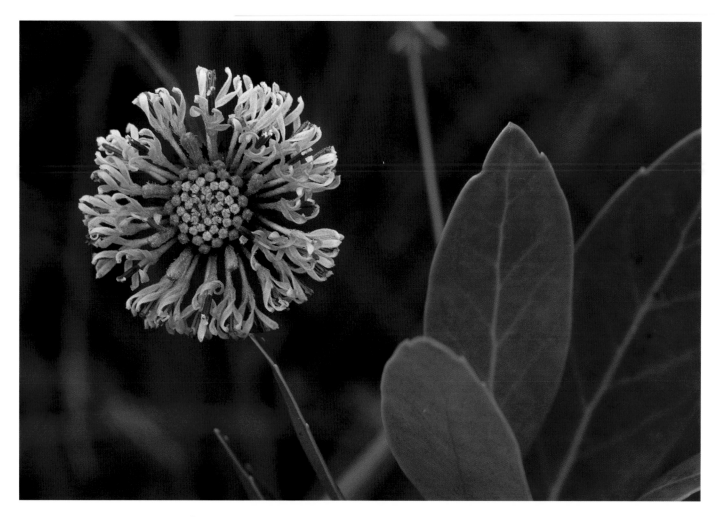

GRASSLEAF BARBARA'S BUTTONS
(*Marshallia tenuifolia*)
General Coffee State Park, August 24

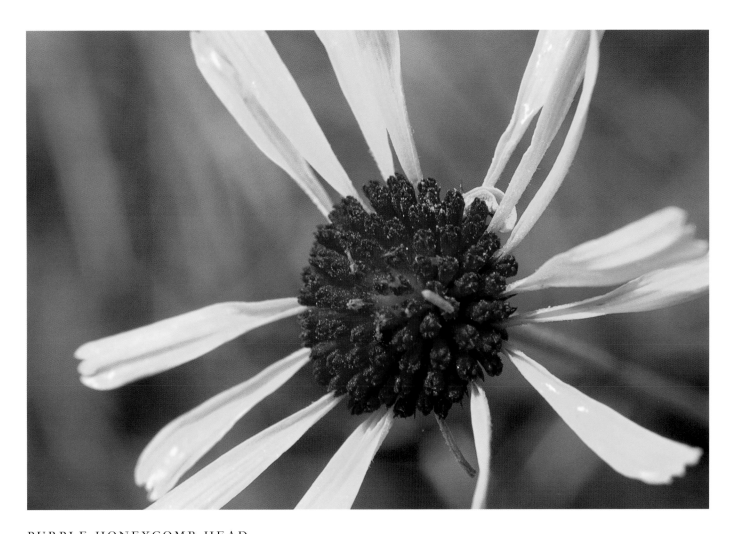

PURPLE HONEYCOMB HEAD
(*Balduina atropurpurea*),
a Georgia protected plant
Tattnall County, September 24

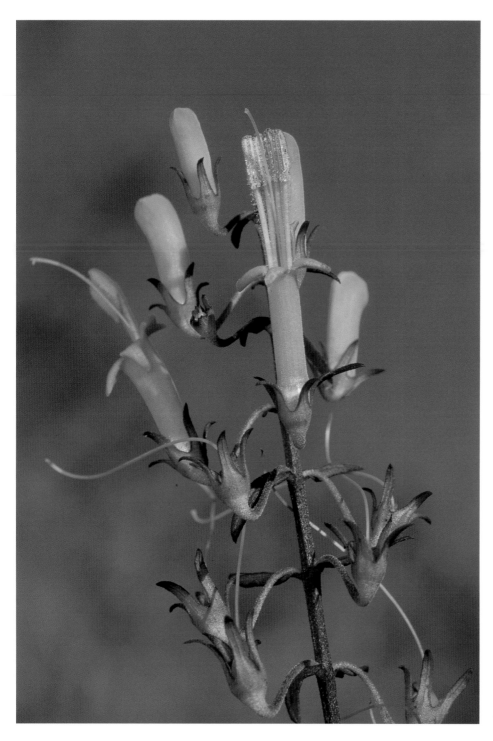

FLAMEFLOWER
(*Macranthera flammea*)
Tattnall County, September 27

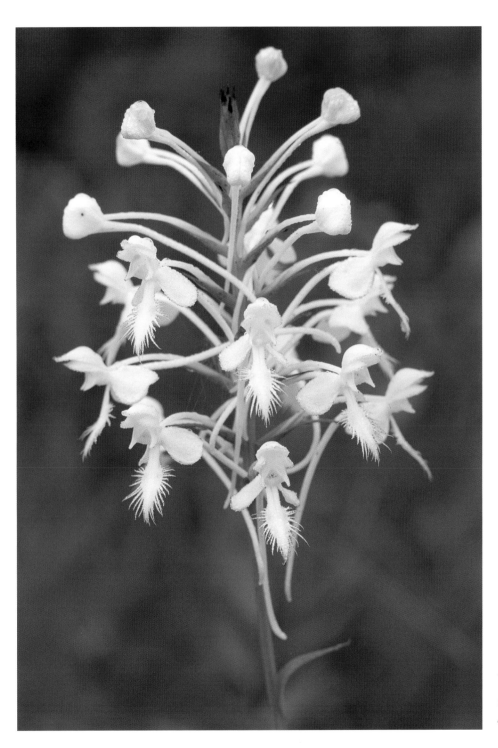

WHITE FRINGED ORCHID
(*Platanthera blephariglottis*)
Taylor County, September 8

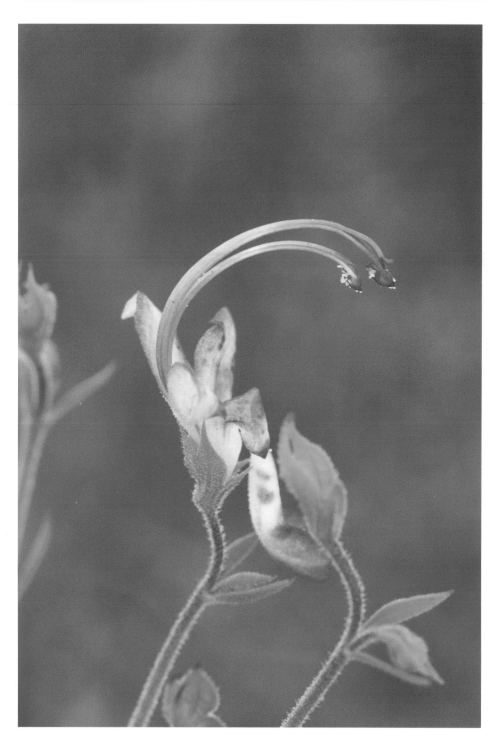

BLUE CURLS

(*Trichostema setaceum*)

Tattnall County, September 27

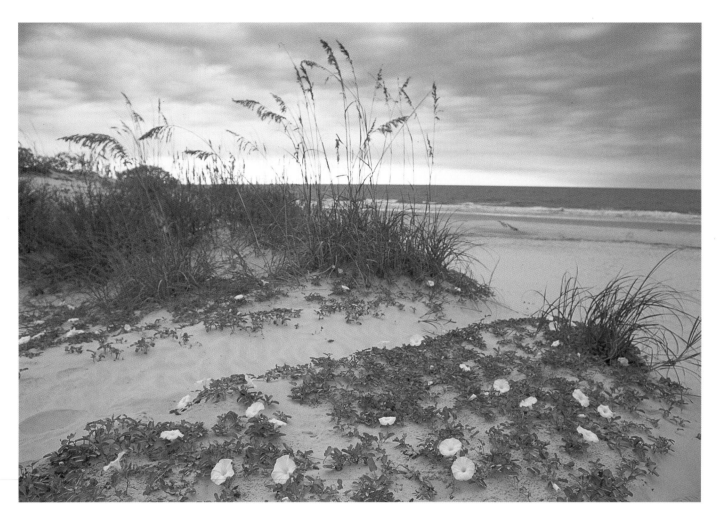

BEACH MORNINGGLORY

(*Ipomoea imperati*)

Jekyll Island, September 10

Overleaf:

PURPLE CONEFLOWER

(*Echinacea pallida*)

Floyd County, June 7

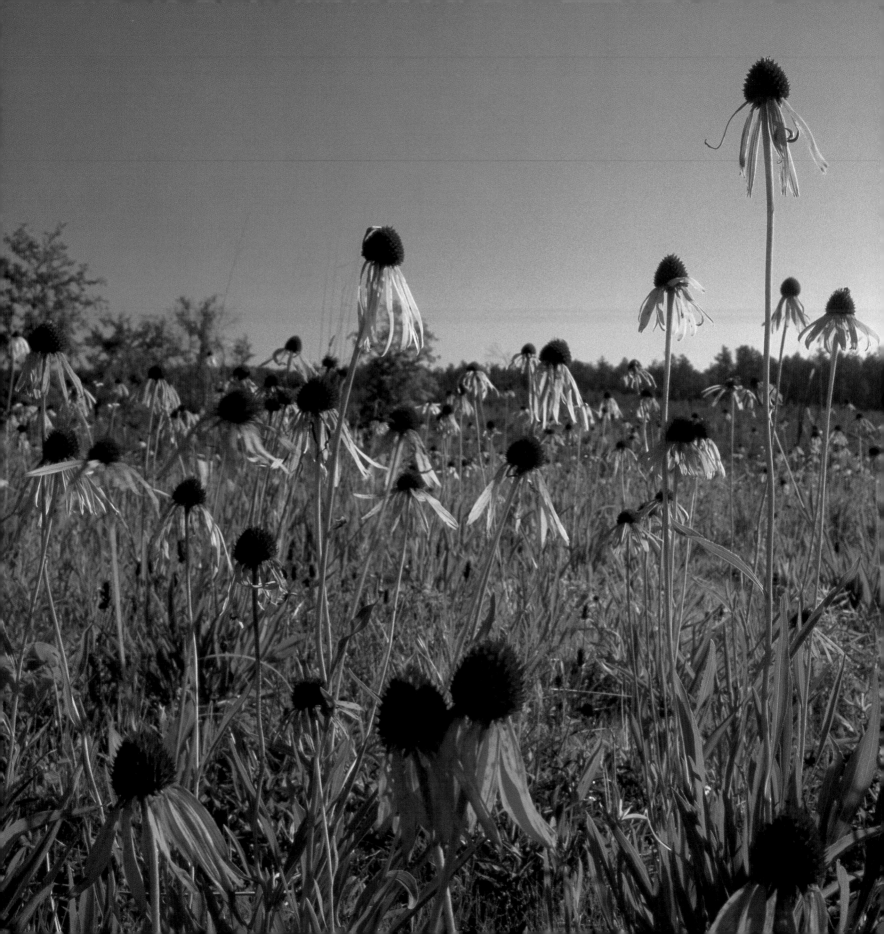

Cumberland Plateau, Ridge, & Valley

D URING THE FIRST WEEK in April, a great spot to see wildflowers is Crockford-Pigeon Mountain Wildlife Management Area (near LaFayette, GA—Davis Crossroads). In this area is the Shirley Miller Wildflower Trail, which provides access to the Pocket Falls and the cove below it. This locale is crowded with wildflowers, so a new boardwalk was built to keep foot traffic from trampling the plants and making new trails. The display of flowers here is overwhelming: celandine poppy (*Stylophorum diphyllum*), Virginia bluebells (*Mertensia virginica*), wild hyacinth (*Camassia scilloides*), decumbent trillium (*Trillium decumbens*), and bent trillium (*Trillium flexipes*) are only a few of the beauties found in the cove.

One special wildflower habitat is the cedar glades located at Chickamauga Battlefield National Military Park (Fort Oglethorpe, GA). Prairie plants that are not usually found in Georgia grow in the thin soil of the limestone outcrops here. We have found St. John's wort (*Hypericum dolabriforme*), prairie clover (*Dalea gattingeri*), stonecrop (*Sedum pulchellum*), and a wild petunia (*Ruellia humilis*) at this site.

Two other interesting wildflower walks in this region are the Keown Falls Trail and the Pocket Recreation Area Trail (Armuchee District, Chattahoochee National Forest, near Calhoun, GA). Both provide excellent displays of spring blossoms. Pink lady's slipper (*Cypripedium acaule*) can be found on the Pocket Recreation Area Trail, and one will spot Jack-in-the-pulpit (*Arisaema triphyllum*) in the spring and bellflower (*Campanula*

divaricata) and whorled-leaf coreopsis (*Coreopsis major*) in the fall at the Keown Falls Trail.

There are two Nature Conservancy preserves in the region, both of which include trails: Marshall Forest and Black's Bluff in the Rome area. The greatest population in Georgia of large-flowered skullcap (*Scutellaria montana*), one of our protected plants, is found in Marshall Forest. To gain access to these areas one must contact the Atlanta Office of the Nature Conservancy.

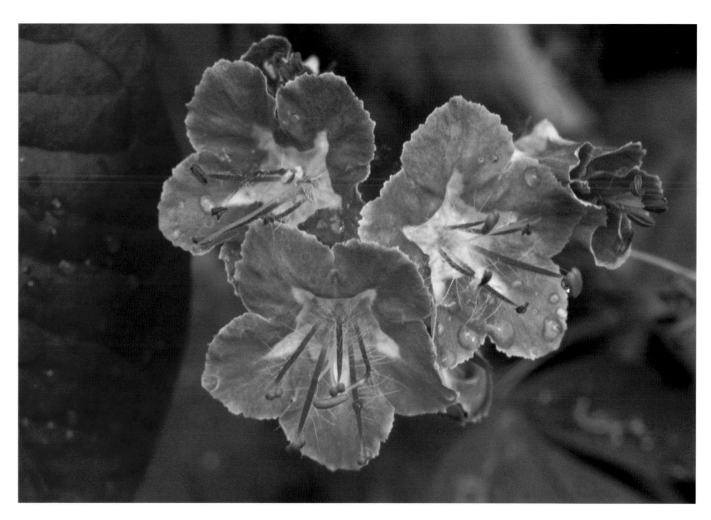

PHACELIA

(*Phacelia bipinnatifida*)

Pocket, Crockford-Pigeon

Mountain Wildlife Management

Area, April 14

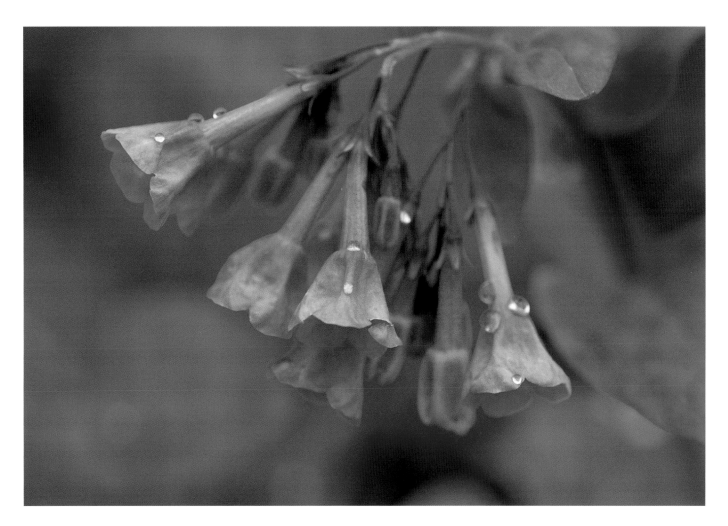

VIRGINIA BLUEBELLS

(*Mertensia virginica*)

Pocket, Crockford-Pigeon

Mountain Wildlife Management

Area, March 29

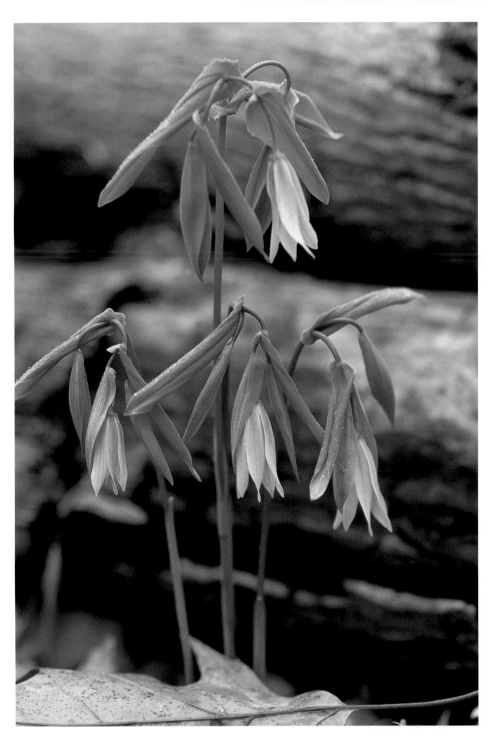

BELLWORT
(*Uvularia perfoliata*)
Black's Bluff, March 30

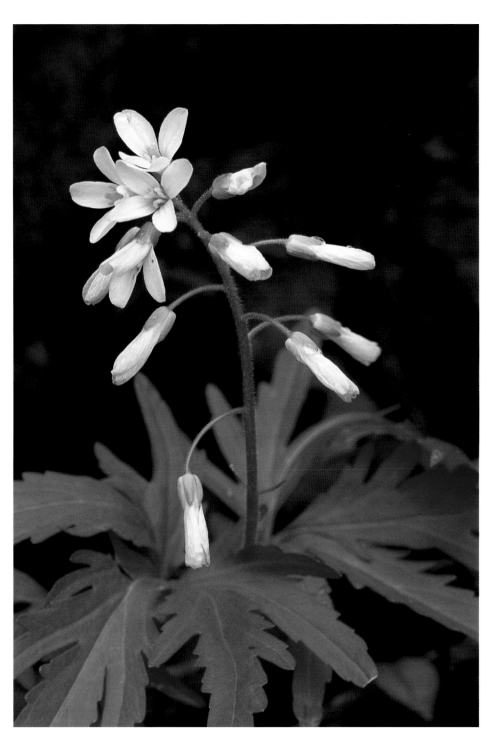

TOOTHWORT
(*Cardamine concatenata,*
formerly *Dentaria laciniata*)
Pocket, Crockford-Pigeon
Mountain Wildlife Management
Area, March 29

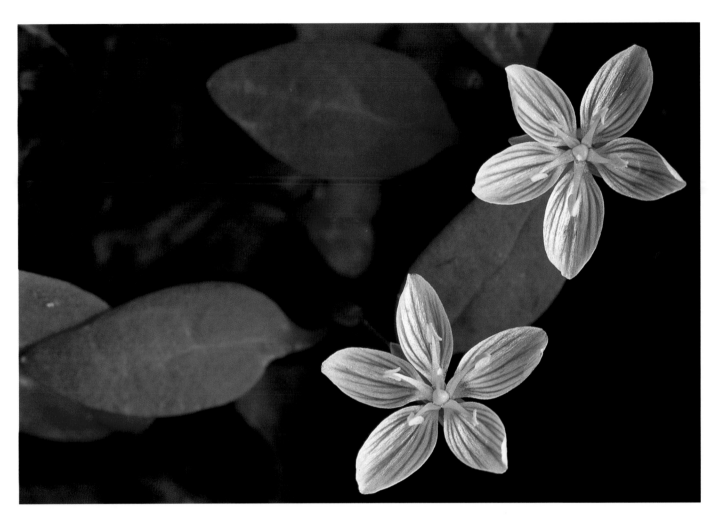

SPRING BEAUTY

(*Claytonia caroliniana*)

Pocket, Crockford-Pigeon

Mountain Wildlife Management

Area, March 29

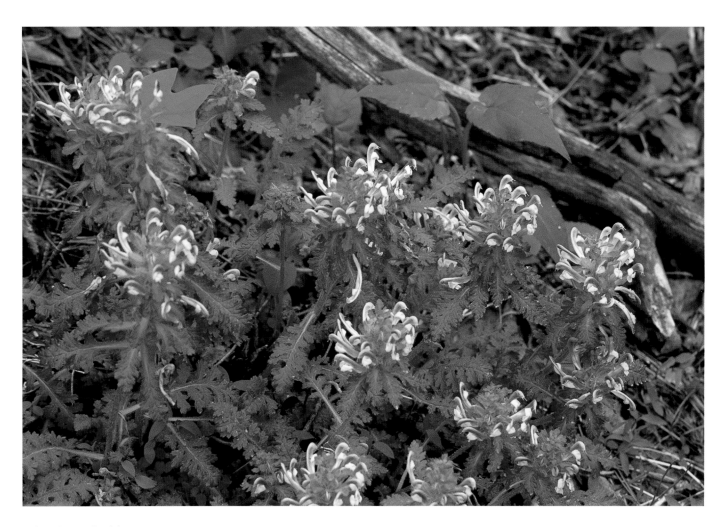

LOUSEWORT

(*Pedicularis canadensis*)

Pocket, Crockford-Pigeon

Mountain Wildlife Management

Area, April 10

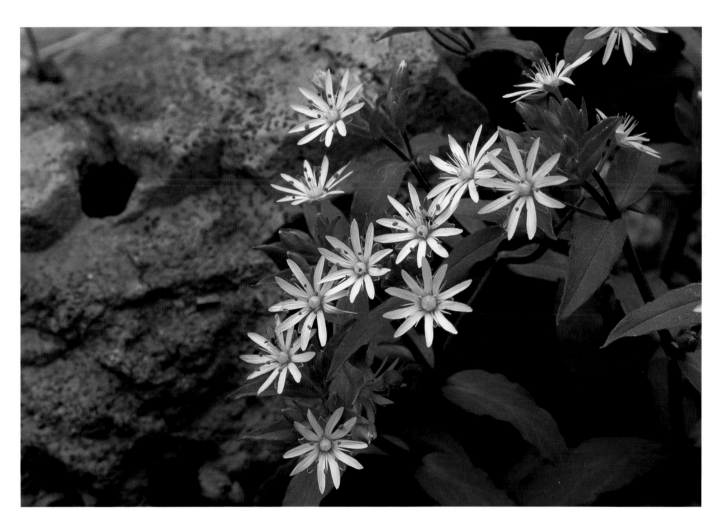

GIANT CHICKWEED

(*Stellaria pubera*)

Pocket, Crockford-Pigeon

Mountain Wildlife Management

Area, March 29

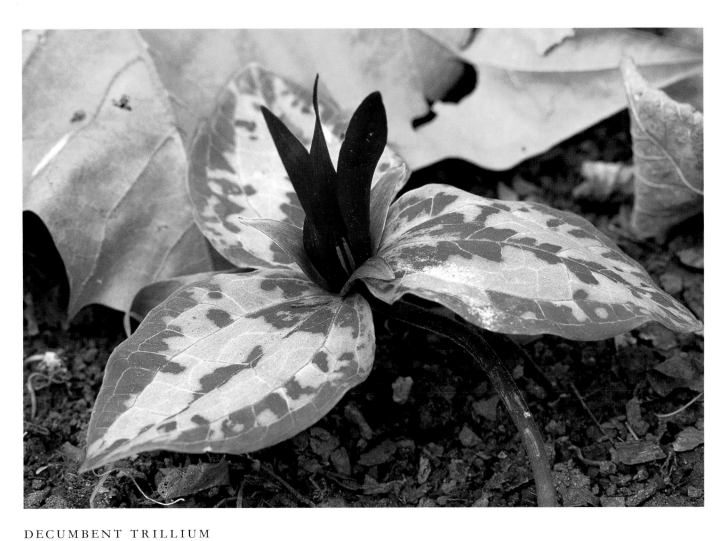

DECUMBENT TRILLIUM
(*Trillium decumbens*)
Pocket, Crockford-Pigeon
Mountain Wildlife Management
Area, April 14

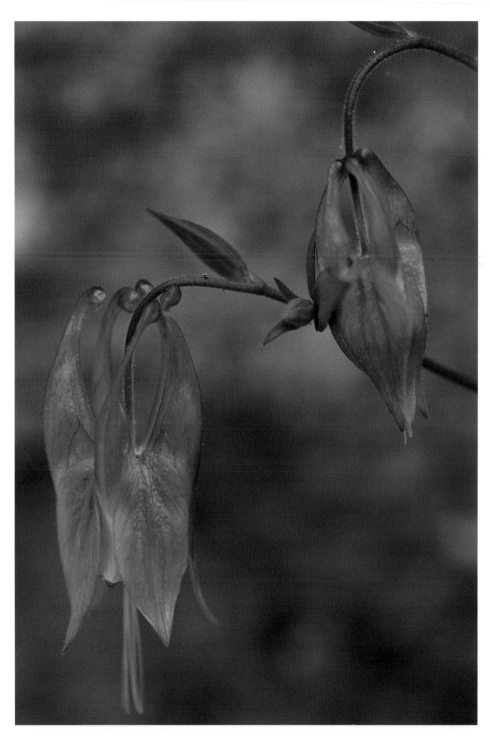

COLUMBINE
(*Aquilegia canadensis*)
Pocket, Crockford-Pigeon
Mountain Wildlife Management
Area, April 14

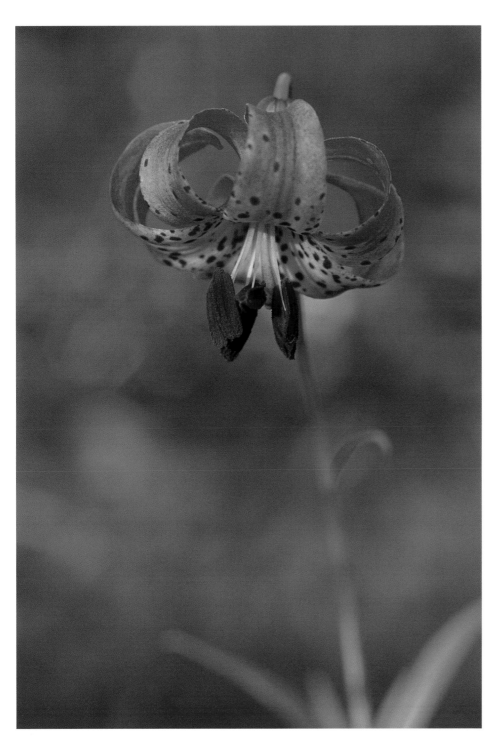

MICHIGAN LILY
(*Lilium michiganense*)
Floyd County, June 7

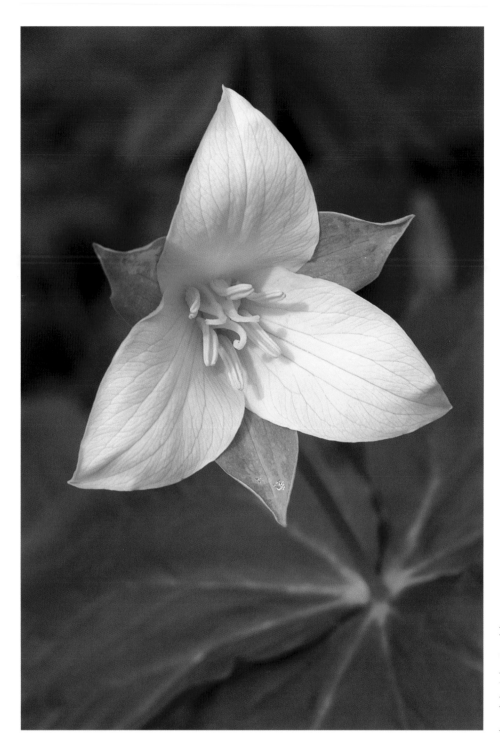

BENT TRILLIUM
(*Trillium flexipes*)
Pocket, Crockford-Pigeon
Mountain Wildlife Management
Area, April 14

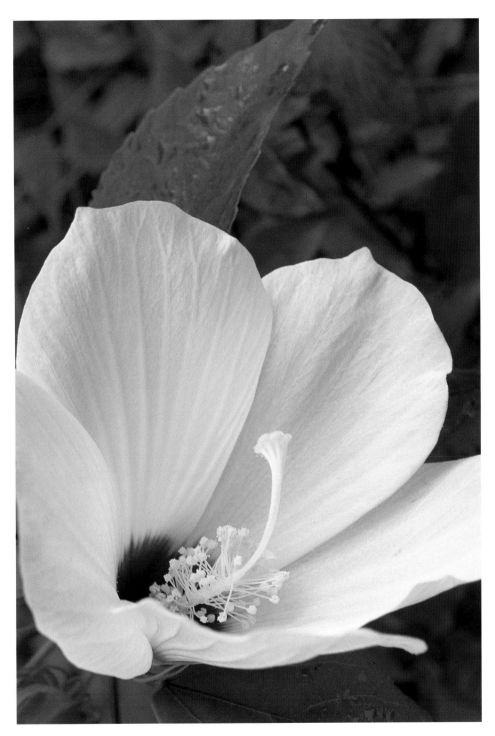

SWAMP ROSE-MALLOW
(*Hibiscus moscheutos*)
Floyd County, July 26

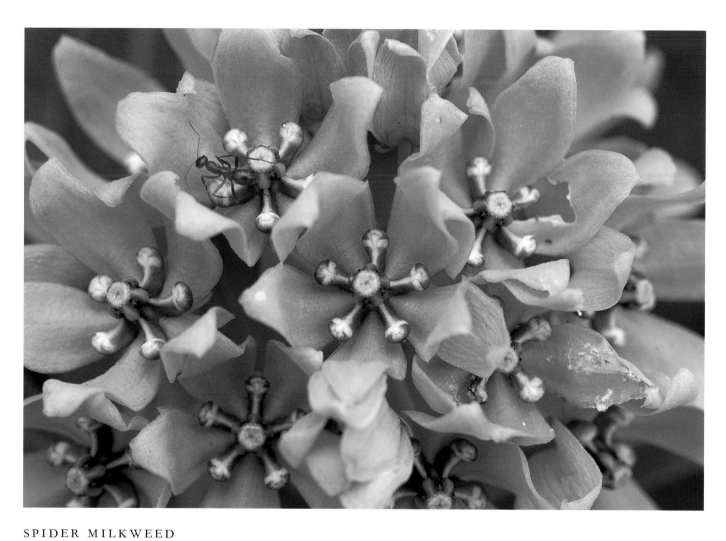

SPIDER MILKWEED

(*Asclepias viridis*)

Chickamauga Battlefield National

Military Park, May 23

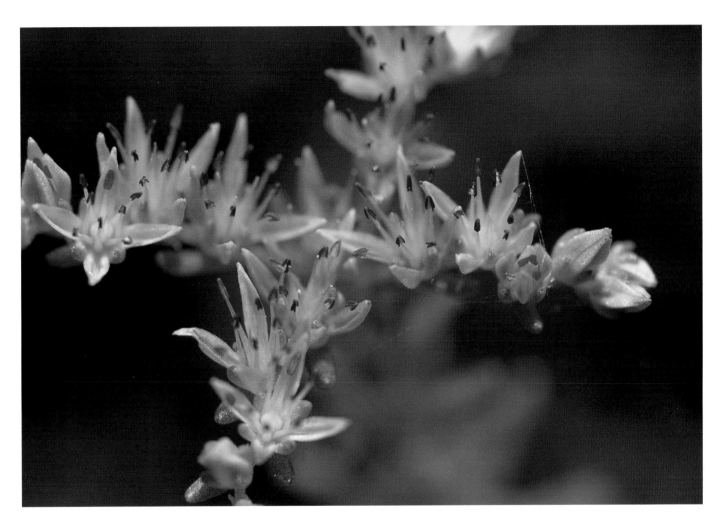

STONECROP

(*Sedum pulchellum*)

Chickamauga Battlefield National
Military Park, May 23

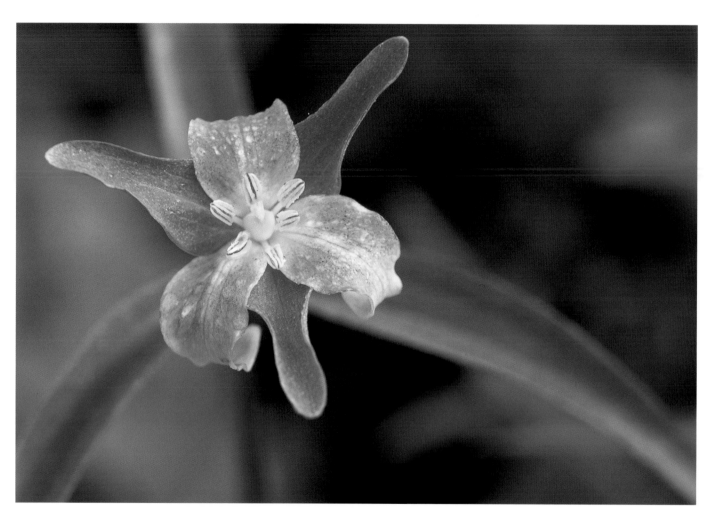

DWARF TRILLIUM

(*Trillium pusillum*)

Whitfield County, April 14

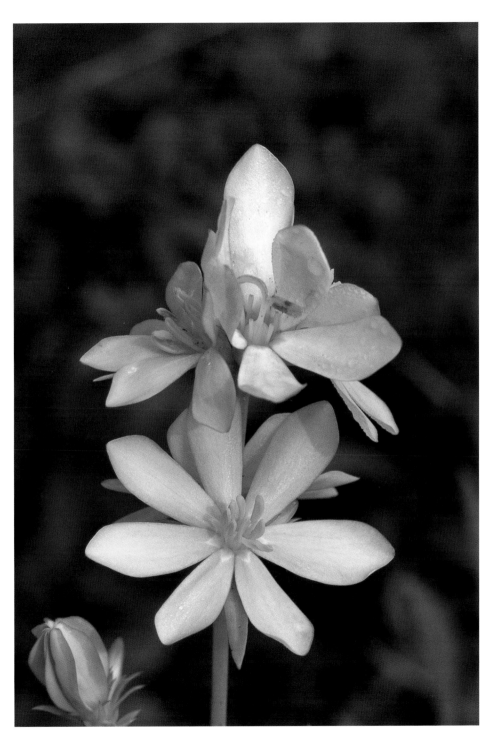

CUMBERLAND ROSE GENTIAN
(*Sabatia capitata*), a Georgia protected plant
Floyd County, July 26

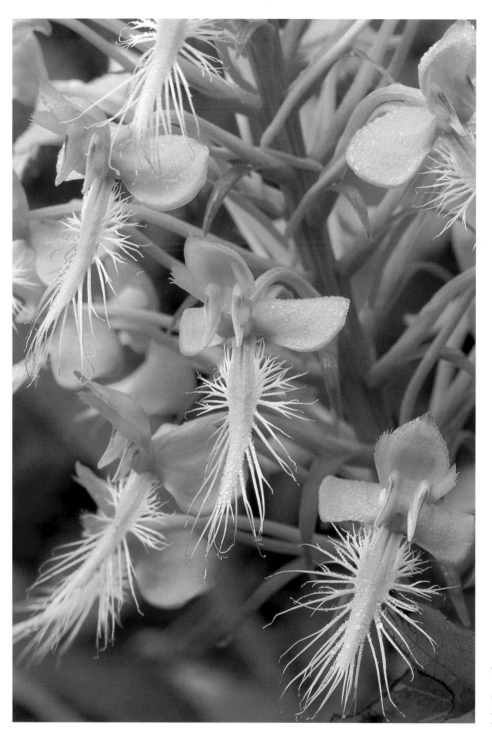

YELLOW FRINGED ORCHID
(*Platanthera ciliaris*)
Floyd County, July 26

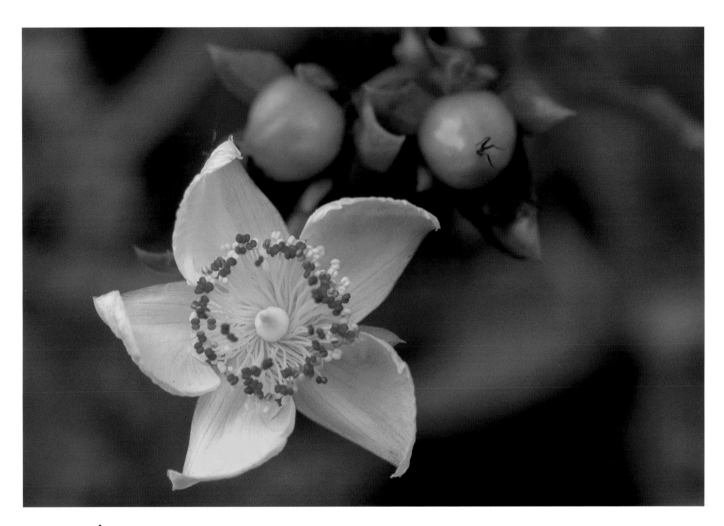

ST. JOHN'S WORT
(*Hypericum dolabriforme*)
Chickamauga Battlefield National
Military Park, August 26

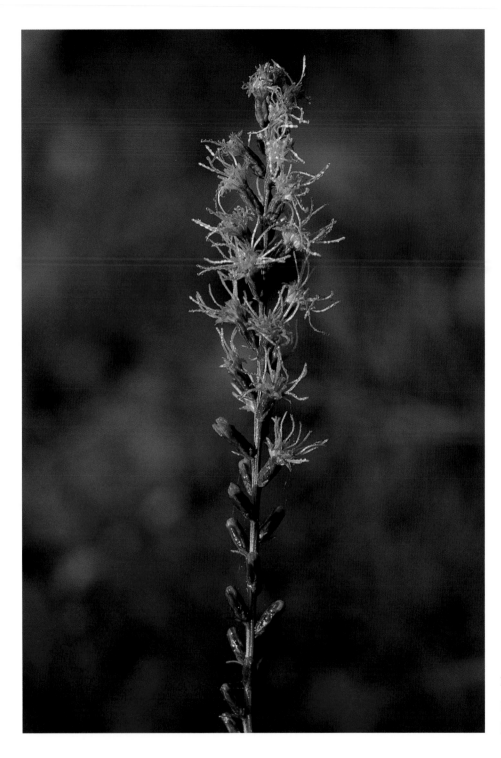

BLAZING STAR
(*Liatris spicata*)
Floyd County, August 23

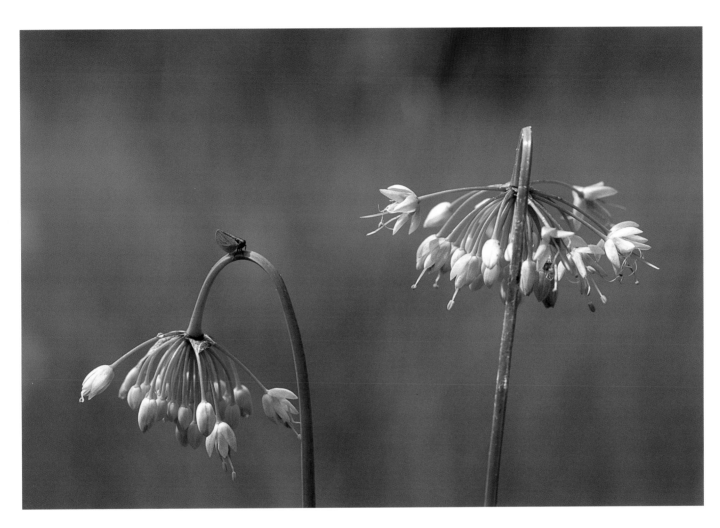

NODDING ONION

(*Allium cernuum*)

Floyd County, July 26

Overleaf:

INDIAN PINK

(*Spigelia marilandica*)

Fannin County, June 24

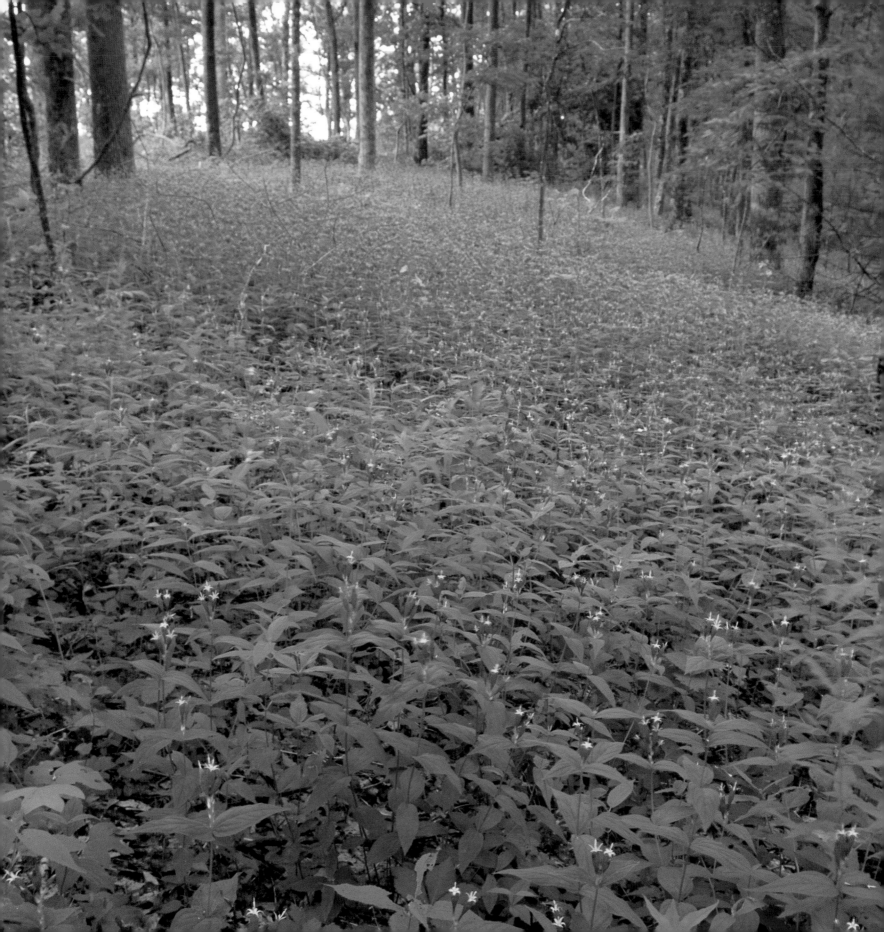

Blue Ridge Mountains

As SPRING AND SUMMER temperatures rise, we tend to head for the mountains to cool off. Our favorite place to visit is Black Rock Mountain State Park (Mountain City, GA). In the park the two-mile Tennessee Rock Trail goes through a number of habitats, including a north-facing cove with a boulder field at the top. The trail is a wonderful site for viewing wildflowers from April through October. One day during the first week of May we found more than a dozen blooming wildflower species, including bellwort (*Uvularia perfoliata*), trillium (*Trillium cuneatum* and *T. erectum*), showy orchis (*Galearis spectabilis*), and pink lady's slipper (*Cypripedium acaule*), a Georgia protected plant. In the summer one can find Michaux's lily (*Lilium michauxii*) and monkshood (*Aconitum uncinatum*), and in the fall gentians (*Gentiana decora*) bloom. In wet areas of the park one can find the beautiful grass-of-Parnassus (*Parnassia asarifolia*).

Nearby is a lower area, Warwoman Dell, a Forest Service picnic area just outside Clayton, Georgia, that has a nature trail. Here trillium (*Trillium vaseyi*), Jack-in-the-pulpit (*Arisaema triphyllum*), bloodroot (*Sanguinaria canadensis*), and other wildflowers blossom throughout March and April before they appear on the top of Black Rock Mountain.

The Forest Service trail to Rabun Bald, near Sky Valley, Georgia, leads past a wide variety of wildflowers, and one is rewarded with a 360° view of the surrounding mountains from the observation deck on top.

The Sosebee Cove Trail (near Vogel State Park, Blairsville, GA) is

only half a mile long, but it weaves back and forth below a boulder field near the top of a north-facing cove. A wildflower photographer's paradise, the trail warrants frequent visits from April through July. Because of the cool climate and the richness of the soil, many plant species more commonly found north of Georgia, such as Dutchman's breeches (*Dicentra cucullaria*) and waterleaf (*Hydrophyllum canadense*), grow in this area.

The Gahuti Trail in Fort Mountain State Park (Chatsworth, GA) is an excellent place to hike in search of wildflowers in the spring. The whole trail is 8.2 miles, but one can take a shorter trip by following the loop (where most of the flowers are found) that begins at the entrance near the visitors center. On this particular trail we have found large yellow lady's slipper (*Cypripedium parviflorum* var. *pubescens*) and lily-of-the-valley (*Convallaria montana*).

There are over five hundred miles of trails in the North Georgia Mountains where one can see wildflowers blooming in season. For the hardy backpacker, the trails in the Cohutta Wilderness area are special. The trails are steep and require many stream crossings without bridges. For other backpacking trips to see spring wildflower displays, one could hike sections of the Appalachian Trail, the Benton Mackay Trail, or the Bartram Trail.

We have also found searching for plants in roadside ditches to be productive in the mountains. Along the road through Track Rock Gap, a petroglyph site near Young Harris, Georgia, the incredibly beautiful and protected fringed gentian (*Gentianopsis crinita*) blooms in October and November. We have also photographed such wildflowers as grass-of-Parnassus (*Parnassia asarifolia*) and cardinal flower (*Lobelia cardinalis*) that we found growing in the ditches along the roads in the Blue Ridge area.

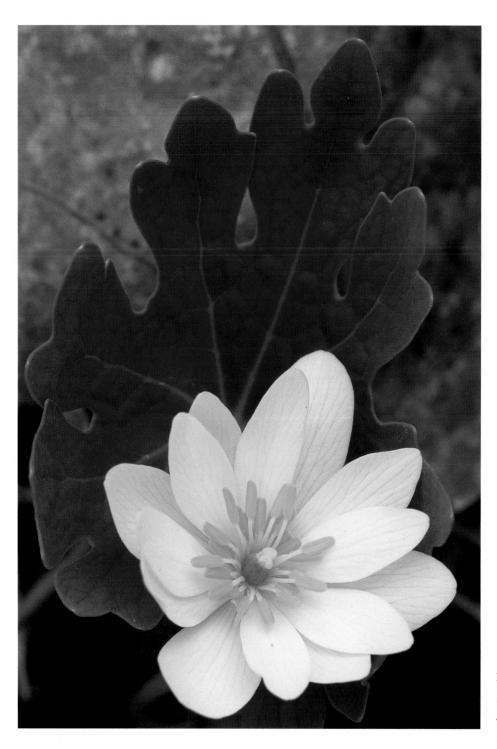

BLOODROOT
(*Sanguinaria canadensis*)
Warwoman Dell, March 18

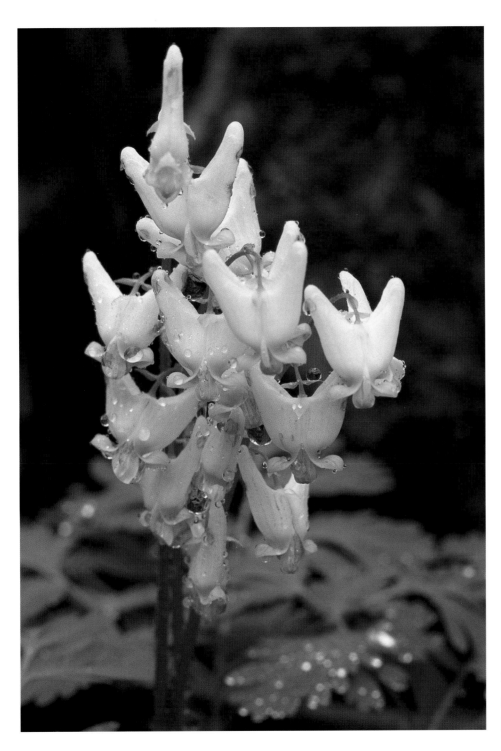

DUTCHMAN'S BREECHES
(*Dicentra cucullaria*)
Sosebee Cove, April 19

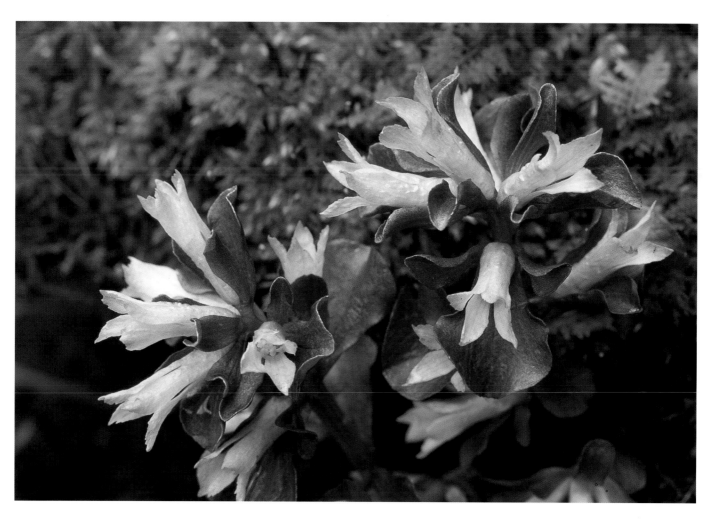

PENNYWORT

(*Obolaria virginica*)

Sosebee Cove, April 26

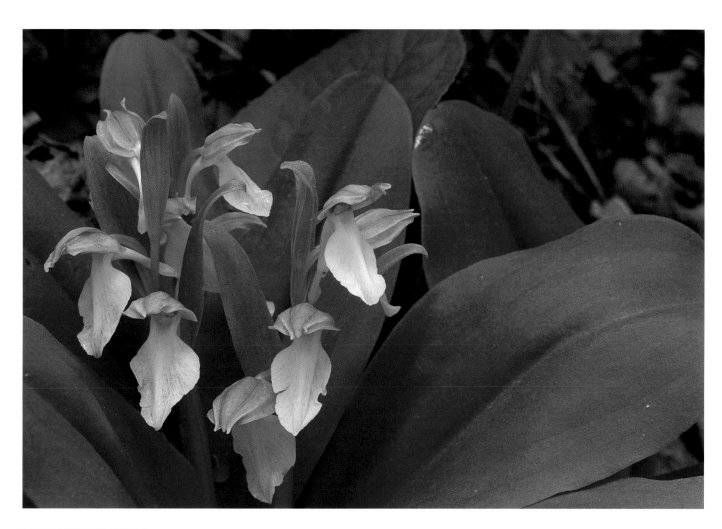

SHOWY ORCHIS
(*Galearis spectabilis*)
Black Rock Mountain
State Park, May 7

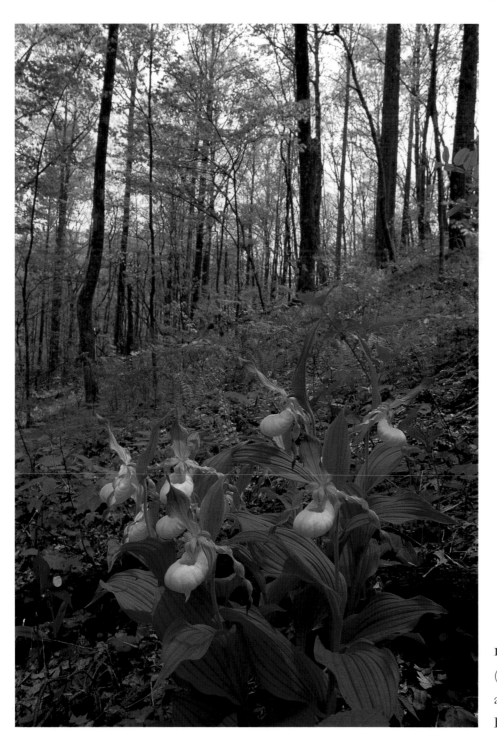

LARGE YELLOW LADY'S SLIPPER
(*Cypripedium parviflorum* var. *pubescens*),
a Georgia protected plant
Lumpkin County, May 6

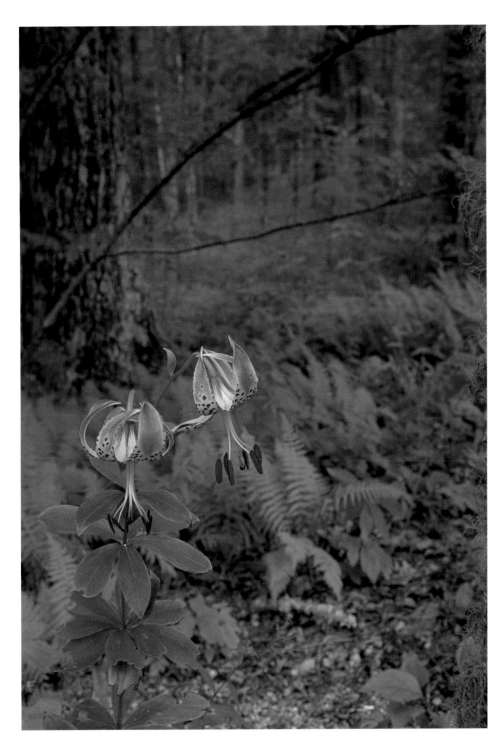

MICHAUX'S LILY
(*Lilium michauxii*)
Black Rock Mountain
State Park, July 30

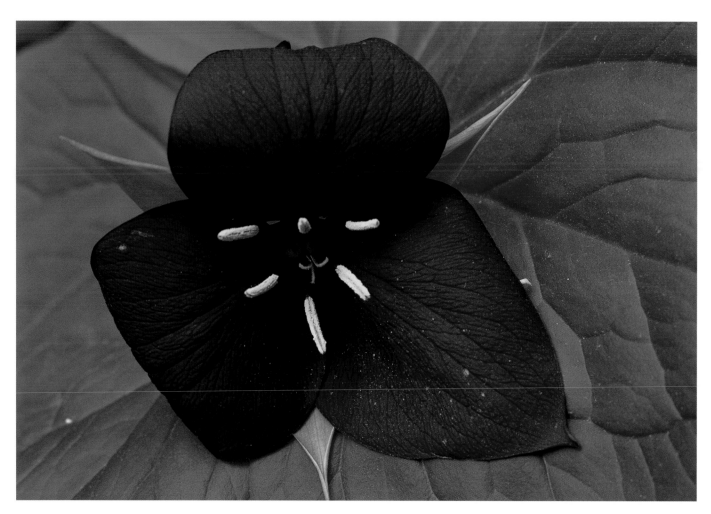

VASEY'S TRILLIUM

(*Trillium vaseyi*)

Warwoman Dell, April 29

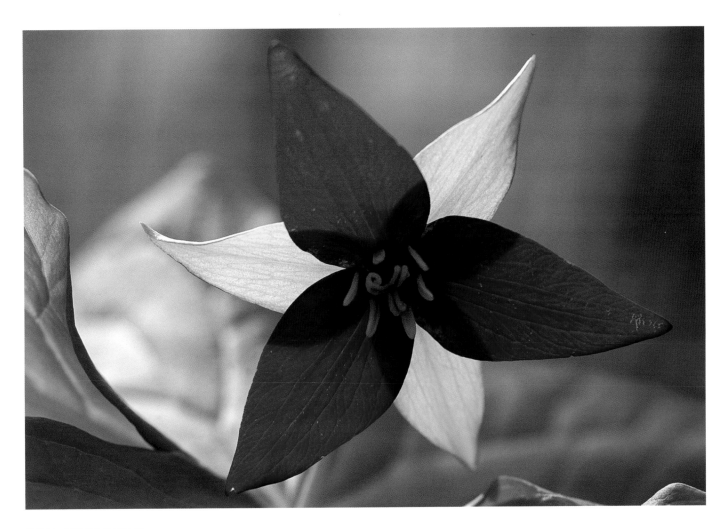

RED TRILLIUM

(*Trillium erectum*)

Black Rock Mountain

State Park, May 7

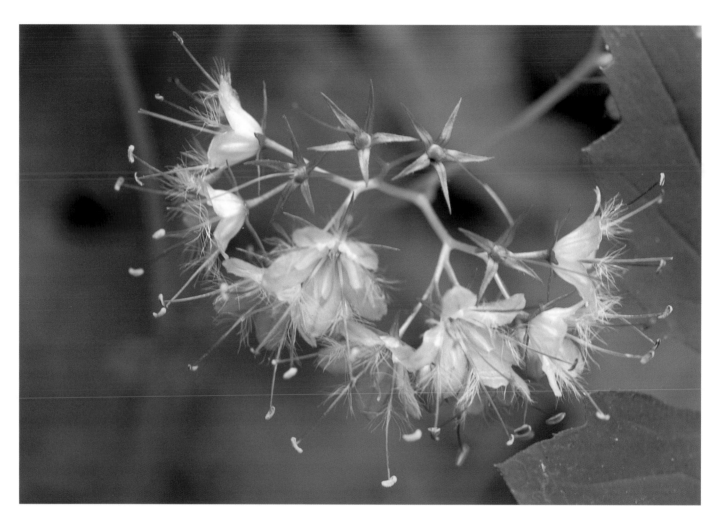

WATERLEAF
(*Hydrophyllum canadense*)
Sosebee Cove, May 30

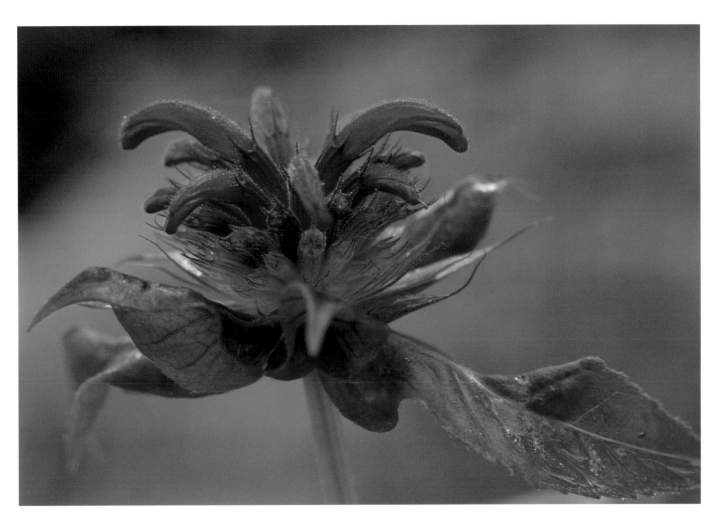

CRIMSON BEE BALM

(*Monarda didyma*), an early bud

Brasstown Bald, July 6

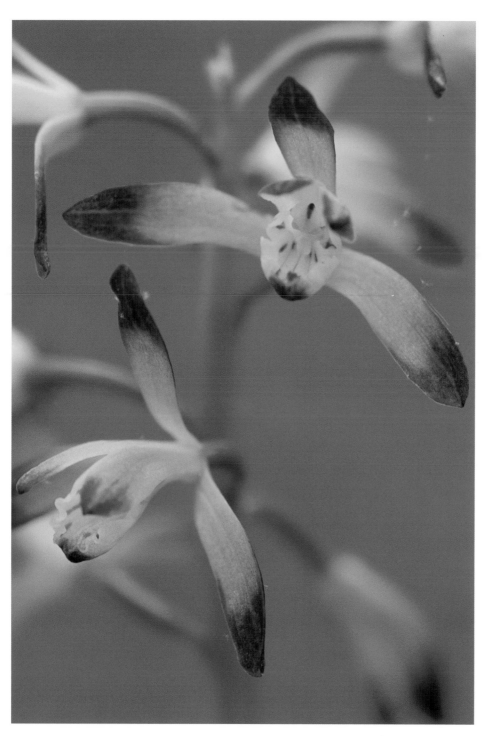

PUTTY ROOT
(*Aplectrum hyemale*)
Black Rock Mountain
State Park, May 18

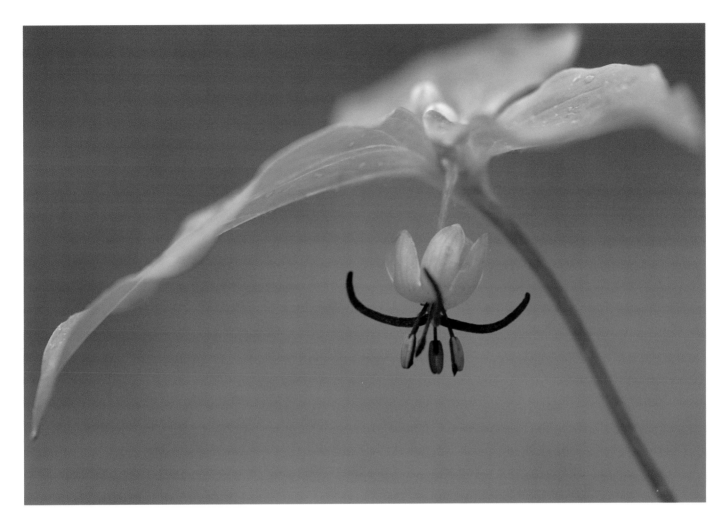

INDIAN CUCUMBER ROOT

(*Medeola virginiana*)

Black Rock Mountain

State Park, May 14

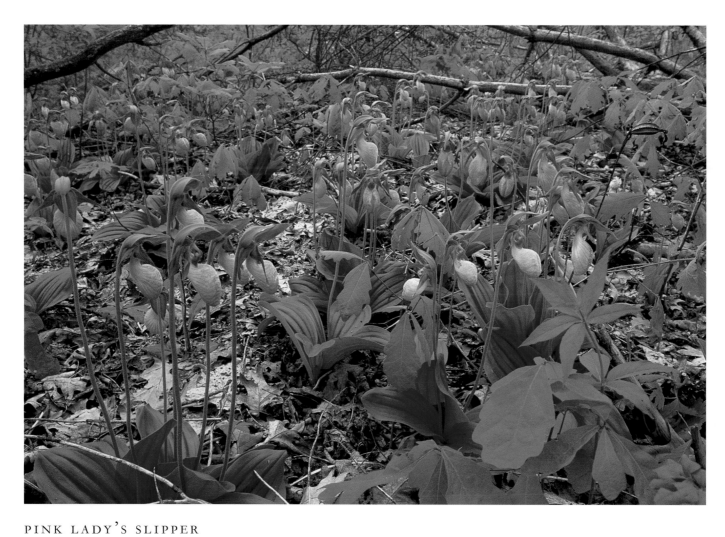

PINK LADY'S SLIPPER
(*Cypripedium acaule*),
a Georgia protected plant
Black Rock Mountain
State Park, May 14

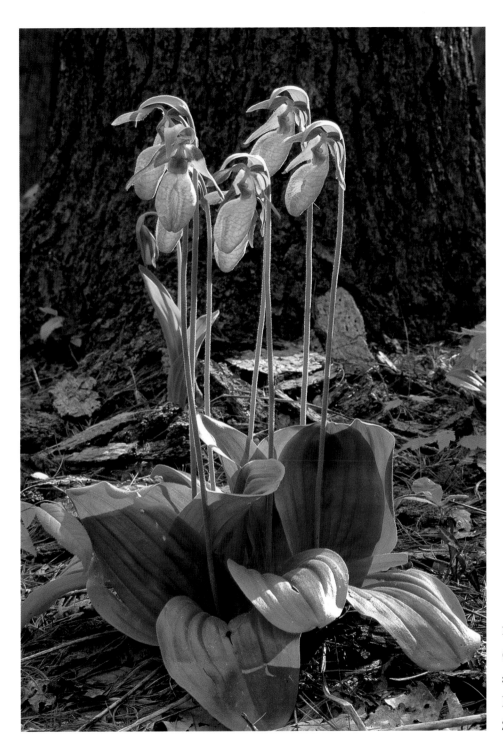

PINK LADY'S SLIPPER
(*Cypripedium acaule*),
a Georgia protected plant
Black Rock Mountain
State Park, May 14

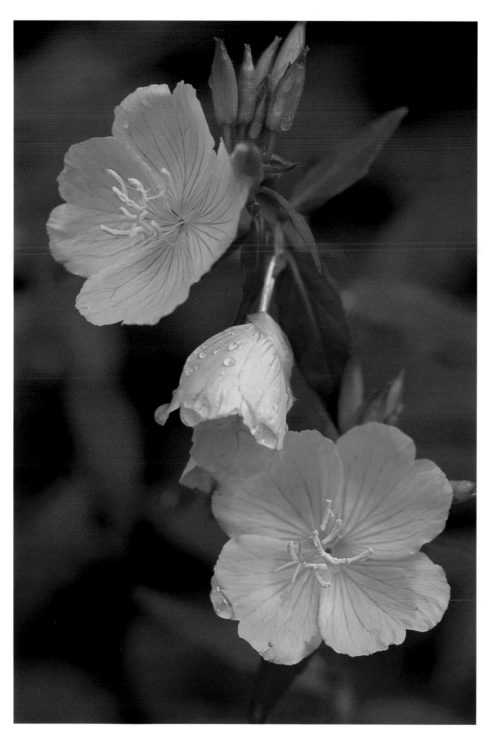

EVENING PRIMROSE
(*Oenothera fruticosa*)
Rabun Bald Trail, June 11

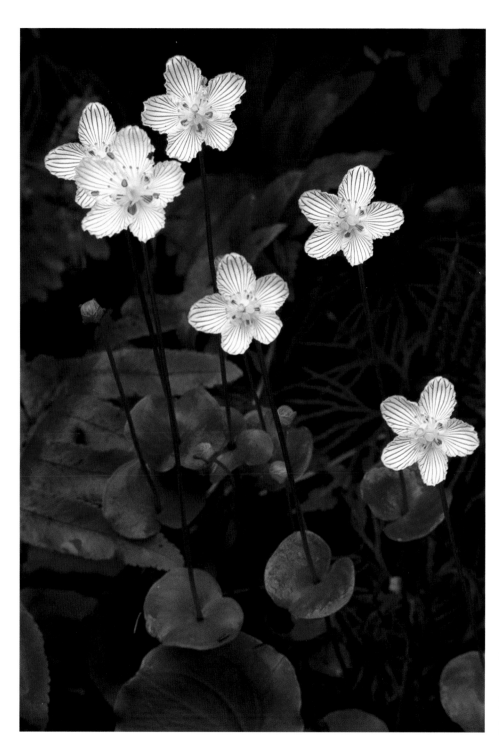

GRASS-OF-PARNASSUS

(*Parnassia asarifolia*)

Black Rock Mountain

State Park, September 27

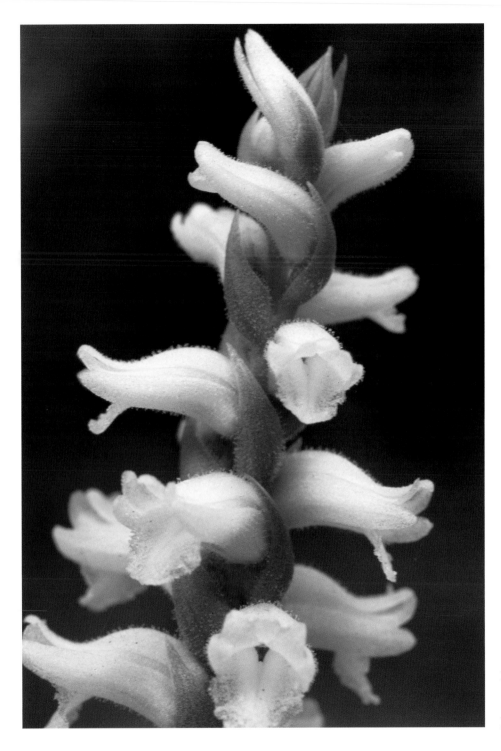

NODDING LADIES' TRESSES
(*Spiranthes cernua*)
Brasstown Bald, October 15

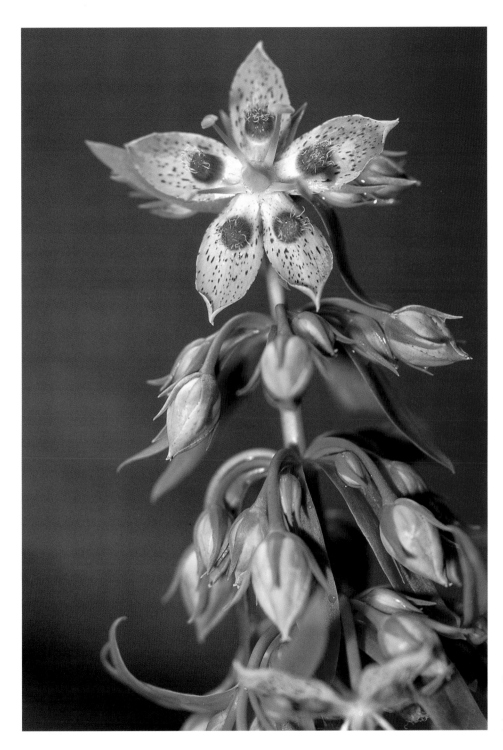

COLUMBO
(*Frasera caroliniensis*)
Lumpkin County, May 20

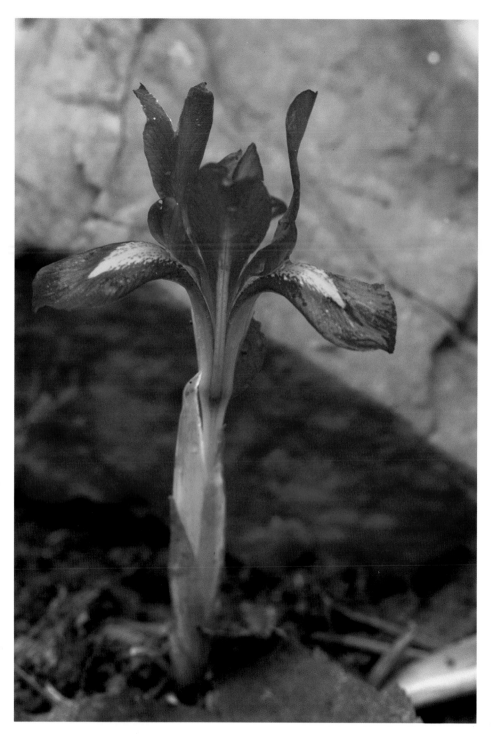

DWARF IRIS
(*Iris verna*)
Amicalola Falls State Park,
April 19

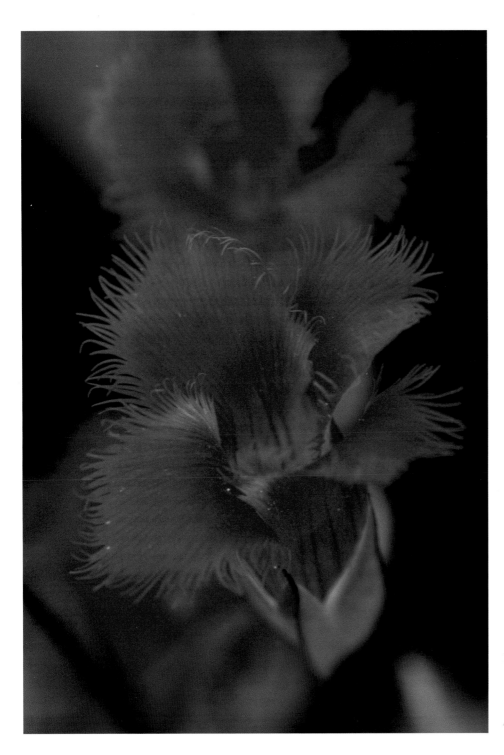

FRINGED GENTIAN
(*Gentianopsis crinita*),
a Georgia protected plant
Track Rock Gap, October 17